SOHO
& THEATRELAND
THROUGH TIME
Brian Girling

AMBERLEY PUBLISHING

Acknowledgements

My grateful thanks go to Maurice Friedman, Allan Hailstone and Janette Rosing for their kindness in allowing me to reproduce images from their collections. Much gratitude is also extended to Ian Vanlint for his additional research and to Westminster Archives Centre for their user-friendly facilities and helpful staff.

Among books consulted were *Soho Past* by Richard Tames, *The Buildings of England: London Vol. 6* by Simon Bradley and Nikolaus Pevsner, and *The London Encyclopaedia* by Ben Weinreb and Christopher Hibbert.

First published 2012

Amberley Publishing
The Hill, Stroud
Gloucestershire, GL5 4EP

www.amberley-books.com

Copyright © Brian Girling, 2012

The right of Brian Girling to be identified as the Author of this work has been asserted in accordance with the Copyrights, Designs and Patents Act 1988.

ISBN 978 1 4456 0202 8

All rights reserved. No part of this book may be reprinted or reproduced or utilised in any form or by any electronic, mechanical or other means, now known or hereafter invented, including photocopying and recording, or in any information storage or retrieval system, without the permission in writing from the Publishers.

British Library Cataloguing in Publication Data.
A catalogue record for this book is available from the British Library.

Typeset in 9.5pt on 12pt Celeste.
Typesetting by Amberley Publishing.
Printed in the UK.

Introduction

As London burned in the Great Fire of 1666, to the west by ancient St Giles and north of royal Westminster, green fields still lay in rural tranquillity. Within a few years, however, a post-fire building boom spawned a new quarter for London on the fields: Soho. The name came from an old hunting cry, but despite its Englishness, this was something different as the new streets attracted a population of Greek Christian and French Huguenot immigrants, already establishing Soho as a foreign district in London.

Further immigrants from Italy, Germany, Switzerland and elsewhere came and left their mark on Soho as it evolved into the unique district it is today.

Aristocracy also found the new Soho to its taste, settling in grand houses around Golden, Leicester and Soho squares before the even grander squares of Mayfair and Belgravia lured the moneyed westwards.

Soho is defined by the narrow streets of tall town houses and the diverse populations who have lived, worked and sought pleasure in them through the centuries. In the nineteenth century, poverty was rife in Soho with overcrowded tenements and craftsmen's workshops in close proximity, but by the end of the 1800s Soho's foreign hotels and restaurants were attracting discerning diners in addition to foreign nationals seeking a taste of their homelands, thereby establishing Soho as London's foremost restaurant quarter.

Soho has always attracted the pleasure seeker and a culture of night clubs, specialist music venues and strip clubs grew up while lively pubs attracted a characteristic mix of artists, actors, writers and the wildly eccentric.

In the 1950s, the Espresso coffee bar, a classic Soho phenomenon, attracted a youthful crowd among which the British rock & roll tradition emerged with Cliff Richard and Tommy Steele among its early stars. Earlier on, Mozart, Canaletto, John Dryden and Karl Marx were among a cavalcade of illustrious former Soho residents, and in 1925 John Logie Baird gave the first demonstration of his new invention, television, at his rooms in Frith Street.

Soho merges into the wider area of the West End's Theatreland as London's principal entertainments district where there are more theatres than can be found anywhere, alongside renowned cinemas famous for their glittering film premières. Leicester Square is at the heart of this world of show business, and close by is Piccadilly Circus where the lights never dim and throngs gather from afar.

For the most part Soho has been spared the character-destroying redevelopment schemes which have afflicted some parts of London. Rebuilding has been on a small scale with the result that, with over 300 years of vibrant life behind them, many Soho streets retain an appealing diversity with each building differing from its neighbour. There are mellow Georgian former town houses next to the eye-catching modernity of media firm's premises and specialist shops with bars and restaurants of all kinds. There is also a narrow byway where the modern form of Soho's traditional sex industry still makes a colourful display, unique in this country.

Berwick Street's cockney market is a reminder that this is London, but in the rip roaring orientalism of Gerrard Street's postwar Chinatown, the capital can seem a world away.

This book explores the Soho of our ancestors with photographs dating from Victorian times to the 1960s set alongside modern images which document some of the changes that have taken place. Some things never change, however, Soho's streets remain as crowded and vibrant as ever.

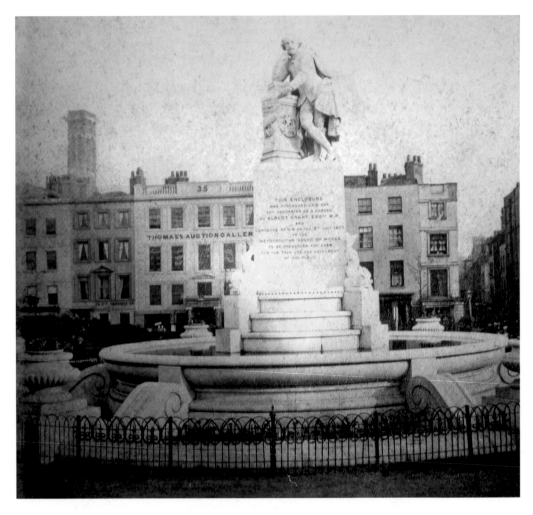

Leicester Square by St Martin's Street, *c.* 1875
The statue of William Shakespeare (1874) with Thomas's Auction Gallery behind it. This is the site of the Royal Dental Hospital (1901), now the Hampshire Hotel.

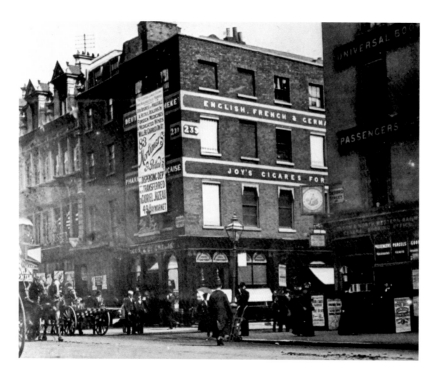

The Site of Oxford Circus Station, Oxford Street by Argyll Street, 1897
In the late 1890s London was on the brink of a transport revolution with a new generation of deep-level electric tube railways about to be built. At Soho's north-western corner an old chemist shop was about to be displaced by a new station complete with a distinctive terracotta finish. The Central London Railway opened its Oxford Circus station on 30 July 1900 and charged a 2d flat fare for any journey between Bank and Shepherd's Bush. The Baker Street & Waterloo Railway added its own station (right) in 1906 with the Victoria line a late arrival in 1969.

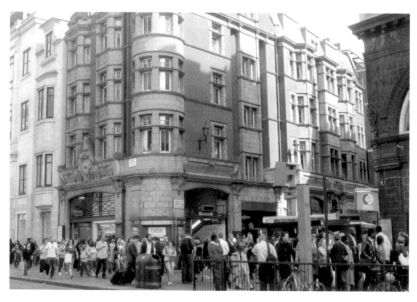

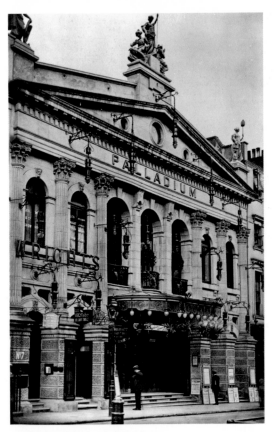

The Palladium, Argyll Street, c. 1912
The Frank Matcham designed Palladium (London Palladium from 1934) opened as a music hall in 1910 on a site previously used by Charles Wengler's circus and a skating rink. The Corinthian Bazaar and Exhibition Rooms had also been located on the site. The theatre has enjoyed ongoing popularity and was once the home of the Crazy Gang – the first Royal Command Performance took place at what was then a new theatre in 1911. The London Palladium sits in the attractively pedestrianised Argyll Street which was first built up from 1737. The modern view reveals part of Great Marlborough Street and Liberty's department store, whose wood-framed construction (1923) features original ship's timbers.

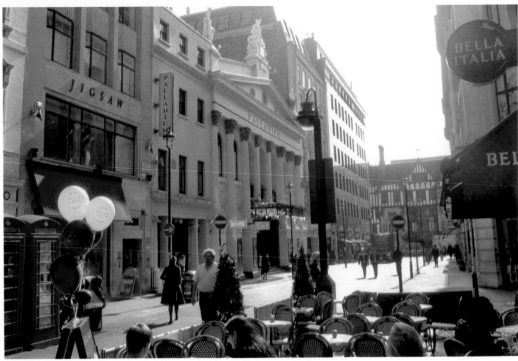

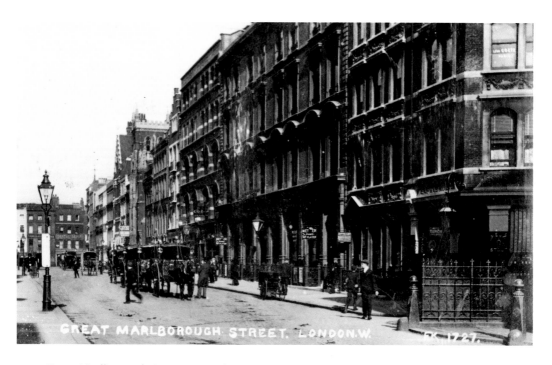

Great Marlborough Street, c. 1906
This broad commercial street offers a contrast to Soho's narrow byways, the Edwardian view revealing lost landmarks including the London College of Music, the church of St John the Baptist (1884–1937) and the Victorian Soho Fire Station. The public toilets, right, have also lost their ornate iron railings and a distant sight of Poland Street shows how a row of shops had blocked off what is now the entrance to Noel Street.

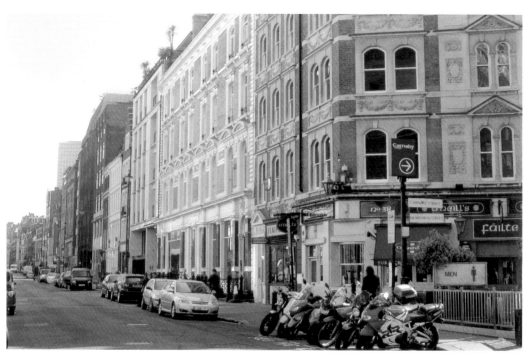

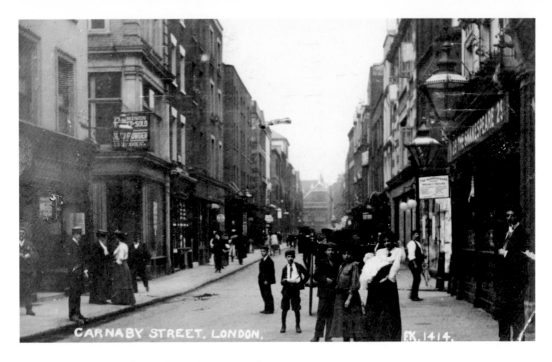

Carnaby Street by Foubert Place, *c.* 1906

Emerging from decades of anonymity, an unremarkable side street behind lordly Regent Street blossomed in the 1960s into a vibrant and colourful centre of teenage fashion – it was Carnaby Street. The first of its boutiques arrived in 1957, and soon a variety of trendy emporia began to replace the old shops, cafés and tailors' workshops as the street acquired worldwide fame amid the psychedelia of the 'swinging sixties'. Today, the strident colours of the 1960s have been muted but the street and its neighbourhood remain a place of pilgrimage for the fashion conscious.

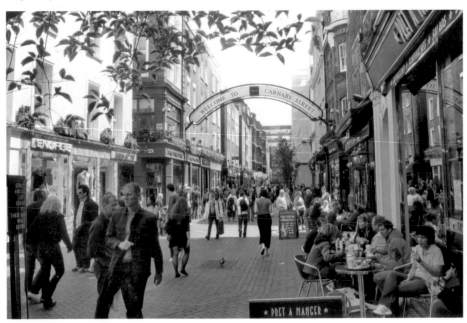

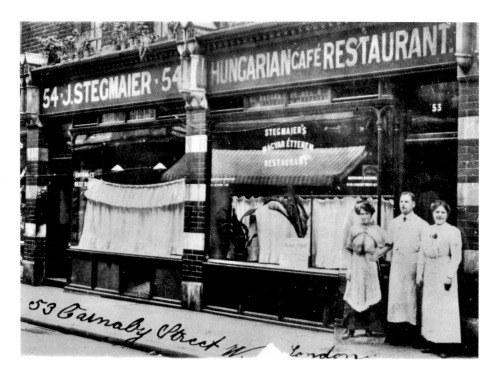

Joseph Stegmaier's Hungarian Restaurant, Nos 53 & 54 Carnaby Street, c. 1908
Soho's restaurants have a long tradition of providing specialist cuisine for its multi-national populations – this was one of a pair of Hungarian restaurants trading in Foubert's Place and Carnaby Street. As ever here, the modern scene is devoted to fashion, the post-war building displaying a plaque which records the activities of impresario Don Arden and the mod band 'Small Faces', who worked here from 1965–67. (Courtesy Maurice Friedman)

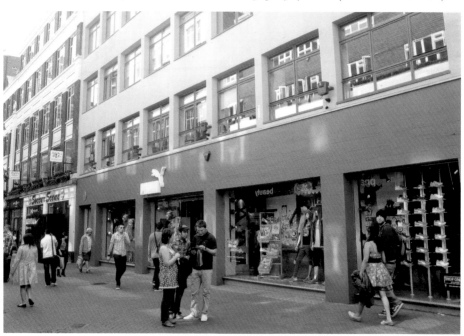

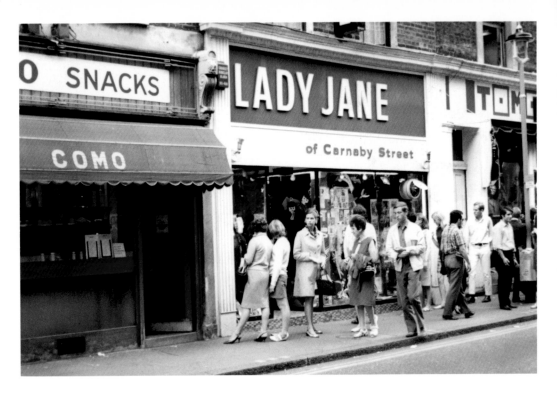

Lady Jane of Carnaby Street, 1960s
This was one of the smart new boutiques which gradually replaced the traditional businesses of former times – Lady Jane's shop had previously been a dairy. The old order still prevailed next door – the Como was a typical Soho snack bar.

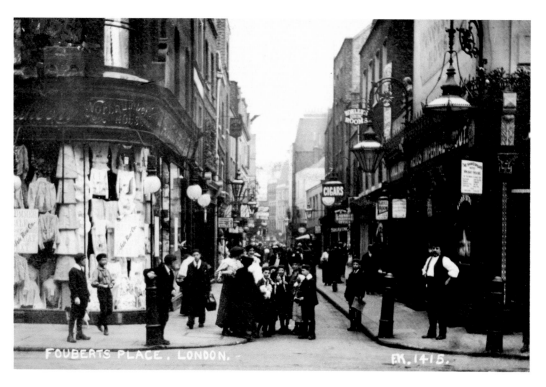

Foubert's Place from Great Marlborough and Carnaby Streets, c. 1906
Once dark and gloomy but full of life, this old byway remains as animated as it was in the days when it was lined by dining rooms, barber shops and other small businesses. Today it is Carnaby Streets promenaders who throng the footway and the Shakespeare's Head pub, which was established around 1735 and rebuilt in 1928. The bard himself appears to appreciate the scene below his corner window in the modern view.

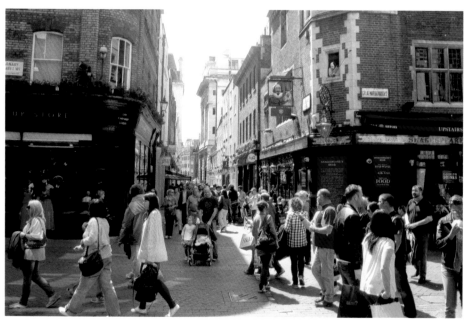

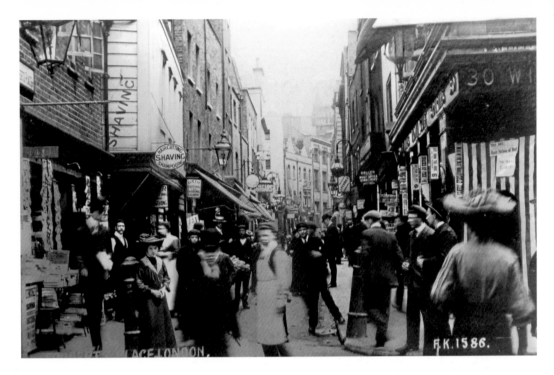

Foubert's Place from Kingly Street, *c.* **1906**
More of this characterful passage showing a weatherboarded wall which hints at the antiquity of the street. It is of seventeenth-century origin and named after a Huguenot family, the Fouberts, who ran a fashionable riding school close by. The wooden wall belonged to Rudolph Modrack's hairdressing saloon – it was formerly a butcher's shop. There is a distant glimpse of Craven Hall, formerly a congregational chapel on the site of Carnaby Market.

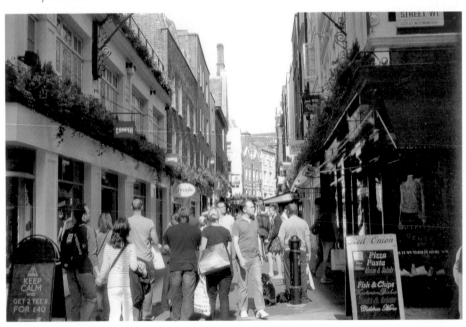

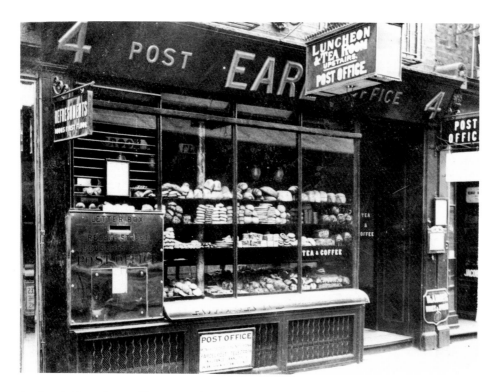

Foubert's Place Post Office, *c.* 1906
Sharing its premises with William Earl's bakery and tearoom, the post office with its polished brass letter box was in the short section of the passageway running between Kingly Street and Regent Street. The individual shops here, including a branch of Hamley's, disappeared with the rebuilding of Regent Street in the 1920s.

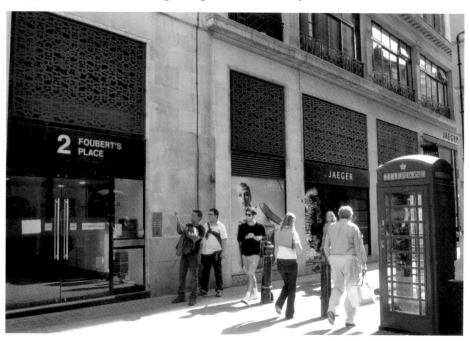

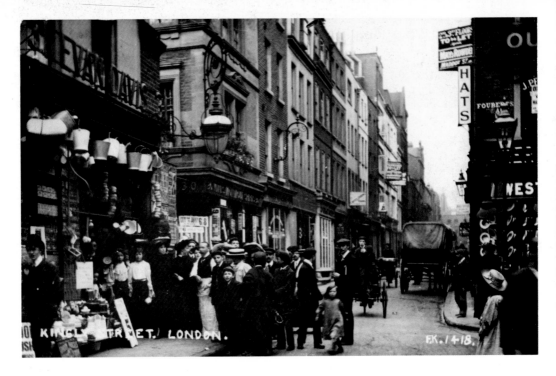

Kingly Street by Foubert's Place, *c.* 1906

This narrow street originated as a footpath running between Marylebone and Piccadilly before being developed as King Street in the 1680s. Now part of the famed Carnaby neighbourhood, it is seen in Edwardian days when Evan Davis' ironmongery store had attracted a crowd.

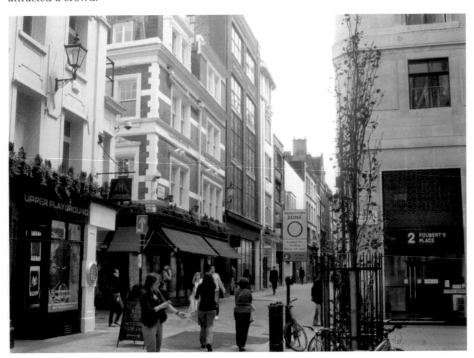

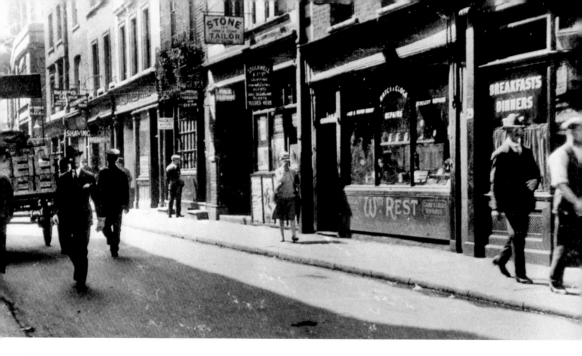

Beak Street near Carnaby Street, *c.* **1922**

The street was built up in the seventeenth century and is named after an original landowner, Thomas Beake, who was one of those who capitalised on the great house-building boom in the years after the Great Fire of London. Despite this, the street was once called Silver Street and from 1749–51 it provided lodgings for the Venetian artist Canaletto. A local pub is called The Sun & Thirteen Cantons, a name which recalls a one-time Swiss community in Soho.

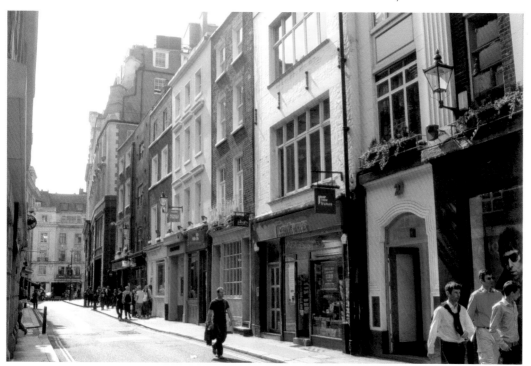

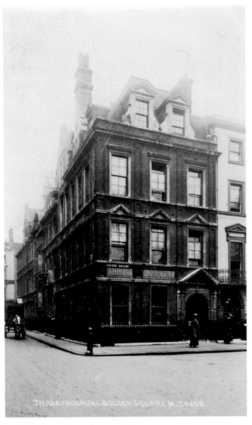

THROAT HOSPITAL GOLDEN SQUARE M. 24438.

The Throat Hospital, Golden Square, *c. 1906*

The modern replacement building is from 1989 and displays a plaque which honours the former hospital as 'the world's first for diseases of the throat'. Treatment began on the site in 1865 with the main hospital arriving in 1882. Golden Square with its terraces of elegant town houses was begun around 1675 and was one of the smartest addresses hereabouts, but as the decades passed commercial interests moved in and many fine old houses were lost. In the present day, a beautiful public garden is a welcome oasis of greenery in this intensely urban quarter of town.

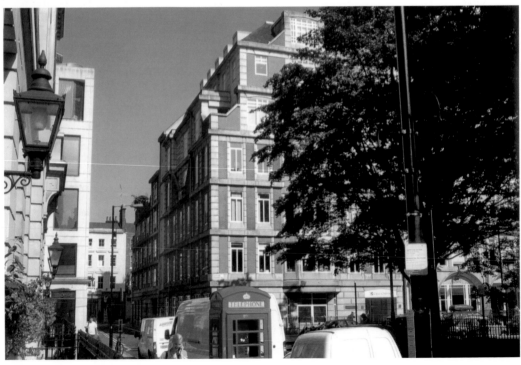

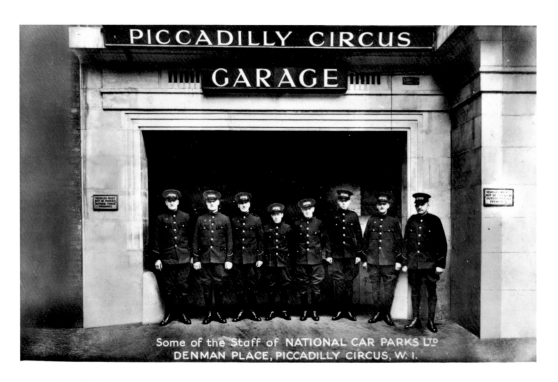

Some of the Staff of NATIONAL CAR PARKS L^{TD}
DENMAN PLACE, PICCADILLY CIRCUS, W. I.

Piccadilly Circus Garage, No. 6 Denman Street, *c.* 1930
In May 1901 the City & Suburban Electric Carriage Company opened what was later claimed to have been Britain's first multi-storey car park. The facility was initially provided by the company for owners of vehicles supplied by them – it came with an electric elevator to serve the garage's seven floors, and with 19,000 square feet of floor space was promoted as 'the largest garage in the world'. Recent demolition has left the site awaiting a new hotel.

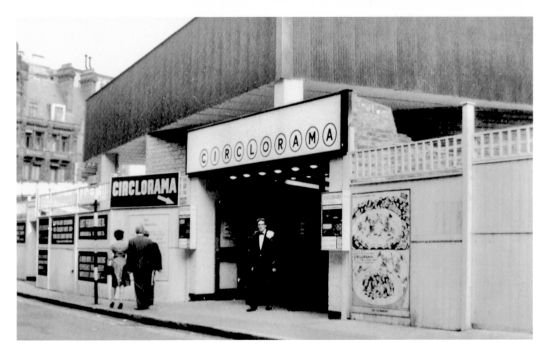

'Circlorama', Denman Street, 1963
This was a temporary experimental cinema built on part of the site of the old Café Monico. As the name suggests, the screens encircled the audience, pre-dating the arrival of the more substantial IMAX cinemas of the present day. Circlorama also had an entrance in Piccadilly Circus, but the show closed in 1965, reopening in 1966 as a conventional cinema, the Classic – this closed in 1976. (Courtesy Maurice Friedman)

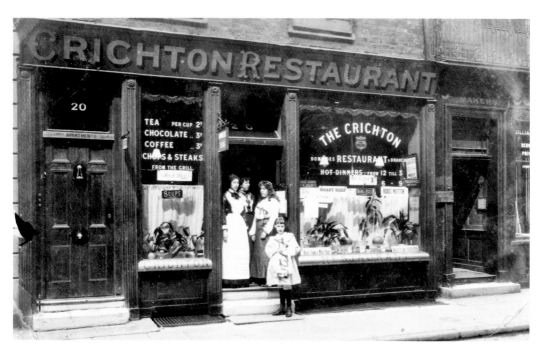

The Crichton Restaurant, No. 20 Brewer Street by Lower John Street, *c.* 1904
Mrs Florence Fraisnais presided over these dining rooms which specialised in traditional British fare and where diners could also enjoy a game of draughts or dominoes. In the floors above there were apartments 'for gentlemen only' while to the right Messrs. Cowderoy, Bland & Co. traded as billiard table makers.

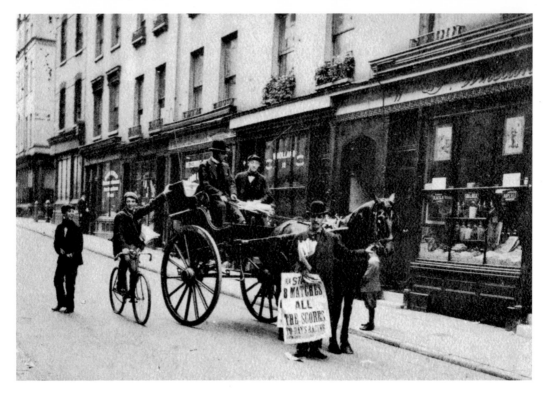

Newspaper Deliveries, Sherwood Street, c. 1900
This was once a street of small shops which included that of newsvendor Richard Walker at No. 2. The building of the Regent Palace Hotel transformed the street from 1912–15, a process continued with the opening of the Piccadilly Theatre in 1928. Sherwood Street's Bridge came in 1934 with an extension to the Regent Palace Hotel.

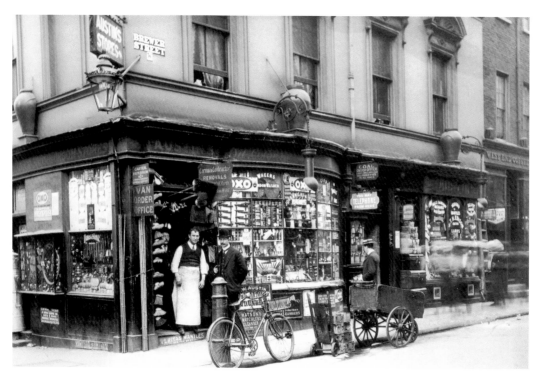

William Austin, Oilman, Brewer Street by Sherwood Street, *c.* 1906

The elegant bow-window displays a vast array of household essentials as was the custom in Edwardian London – the business also had branches in Rupert Street and Pall Mall. Building works for the Regent Palace Hotel from 1912 swallowed up this entire Soho block including Austin's and the West End Coffee Company next door. The hotel has now departed but elements of it have been preserved to front a new development. (Courtesy Janette Rosing)

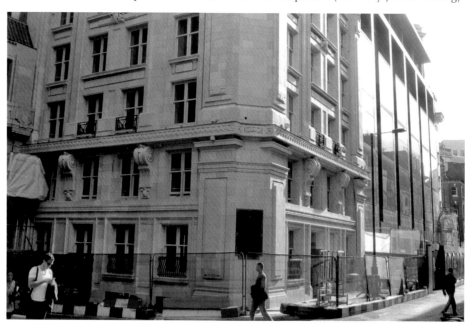

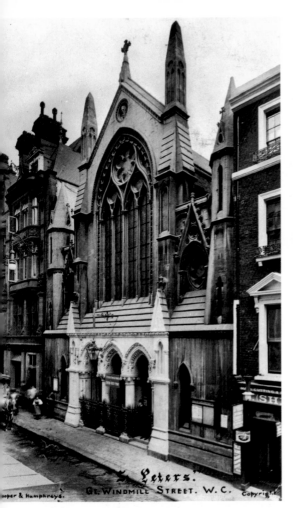
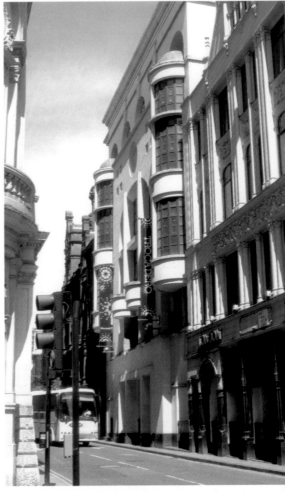

St Peter, Soho, Great Windmill Street, _c._ 1908

While much of Soho originated as a grid of seventeenth- and eighteenth-century streets, Great Windmill Street was older, its course once that of a rustic footpath leading to a substantial windmill put up in the 1500s. Development lined the street with houses from the 1600s but Great Windmill Street was cut into two sections by the building of Shaftesbury Avenue from 1884–86. What is now the short southern part was dignified in 1861 by the arrival of the richly Gothic St Peter's church designed by Raphael Brandon – it was adjacent to an early manifestation of the street's show business heritage, the Trocadero Music Hall (1820). The church lasted until 1954 after which the site was used for later versions of the Trocadero's dining and entertainments complex. The street's northern section is noted for the Windmill Theatre which gained popular following for its nude reviews – it began life in 1909 as the Palais de Luxe Windmill Cinema.

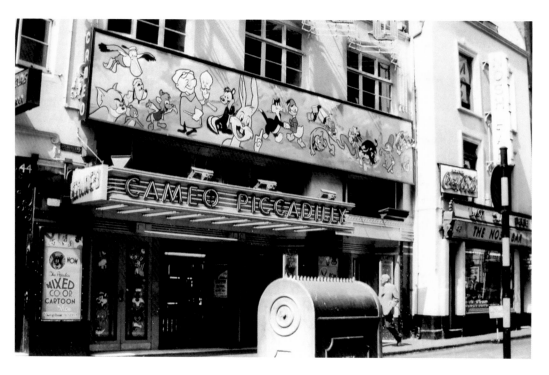

The Cameo Piccadilly Cinema, Great Windmill Street, 1960s
Despite its modern look the Cameo had a lengthy ancestry, opening as the Piccadilly Circus Cinematograph Theatre in 1910. The cinema flourished as a news theatre in the 1930s, and from the 1960s, with a series of name changes including Cameo Moulin and Cannon Moulin Complex, the cinema thrived on a diet of x-rated sex films. The old pleasure palace finally closed in 1990, its former premises adapting to new roles. (Courtesy Maurice Friedman)

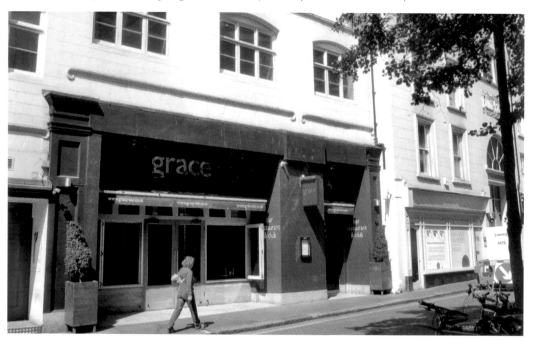

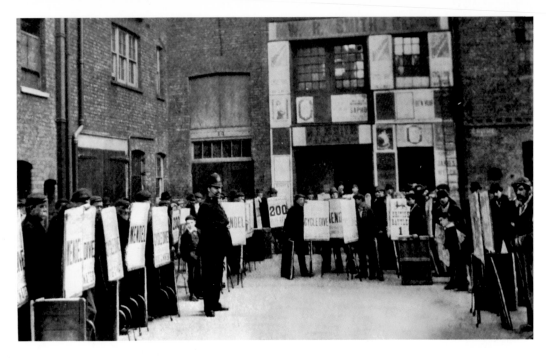

Sandwich Men, Ham Yard, Great Windmill Street, *c.* 1900

These gentlemen with their placards have long been a feature of London's streets but with modern advertising methods they are no longer as prolific. Here a contingent of them has lined up for their pay at the premises of advertising contractors William Ryan Smith. In 1900, Ham Yard was a pocket of deprivation and small-scale industry with several gun makers and engineers' premises set alongside the Ham Yard Soup Kitchen & Hospice.

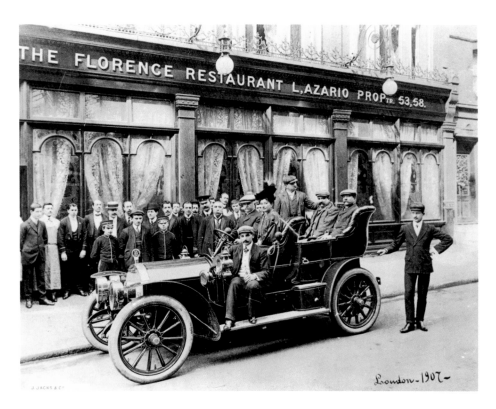

The Florence Restaurant and Hotel, Rupert Street, 1907

Luigi Azario's well-staffed Italian restaurant enjoyed great popularity through the first decades of the twentieth century and was something of a celebrity haunt in its day. One patron who was welcomed with great ceremony was Pietro Dorando, the Italian runner whose heroics at the London Olympic Games in 1908 enthralled the nation.

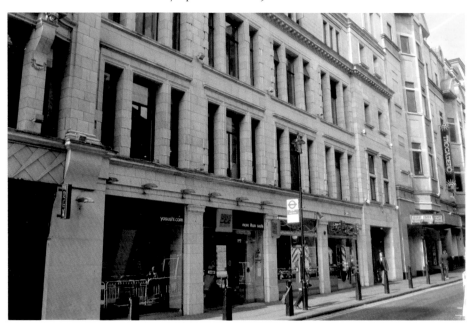

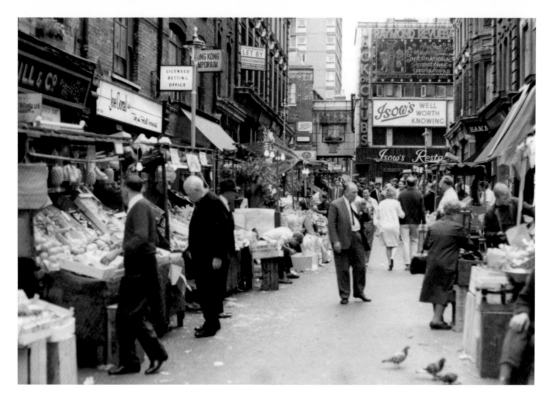

Rupert Street from Archer Street, 1960s
A traditional fruit and vegetable market and a range of domestic stores enlivened the street in the 1960s. There is a glimpse of distant Walker's Court and Brewer Street with Isow's, the popular Jewish restaurant, and the iconic Raymond Revuebar as run by the 'King of Soho', Paul Raymond, from 1958.

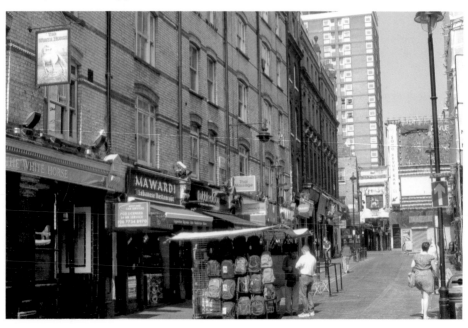

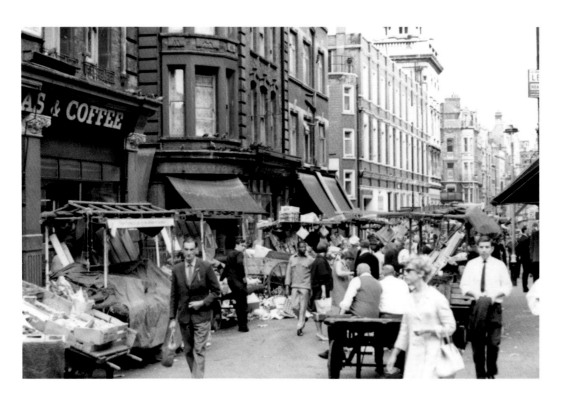

Rupert Street, 1960s

The old domestic market has dwindled in the present day leaving fewer but more specialised businesses to carry on the market tradition. To the left is Tisbury Court (originally Little Crown Court) with R. C. Hamnett's provisions store on the further corner. Further down is part of the Globe Theatre which began life in 1906 as the Hicks Theatre – its name changed in 1909 and again in 1994 when as the Geilgud it honoured actor Sir John Geilgud.

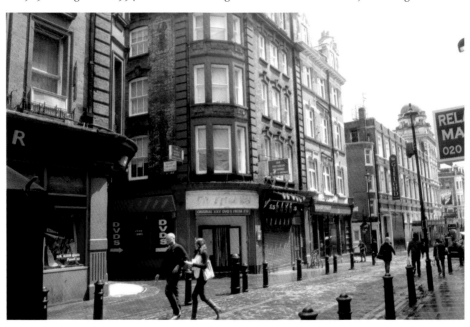

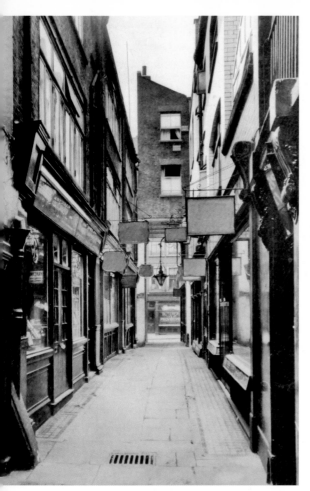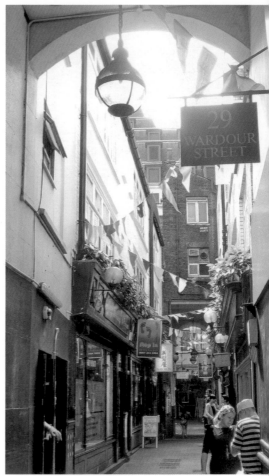

Rupert Court from Wardour Street, *c. 1920*

Connecting Wardour and Rupert Streets, this narrow alley was once populated by coppersmiths, spectacle makers and other specialist traders, but in modern times it is a fragrant byway in Soho's Chinatown complete with Oriental restaurants and hairdressing saloons. The Rupert names here come from Prince Rupert who was First Lord of the British Admiralty when building began here in 1676 – the southern section of Wardour Street was called Princes Street at that time. The archway from Wardour Street from which these images were taken runs beneath a well-preserved building of 1728 vintage while at the further end of the court, the Blue Posts pub reaches back to 1739.

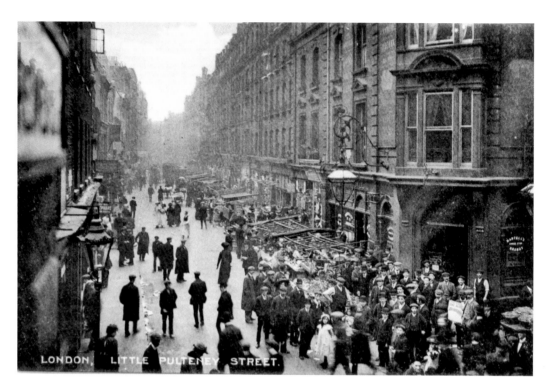

Little Pulteney Street (Brewer Street), by Great Windmill Street, *c.* 1910

The street's earliest name, Knave's Acre, was picturesque enough but did not reflect the respectability sought by its later title, Little Pulteney Street – a further change in 1938 extended Brewer Street eastwards to Wardour Street. Barrow boys and costermongers gave the street typical vibrancy and although the street traders have long gone, St James's Residences dating from 1885 (above the shops) endure as does the Duke of Argyll pub, right.

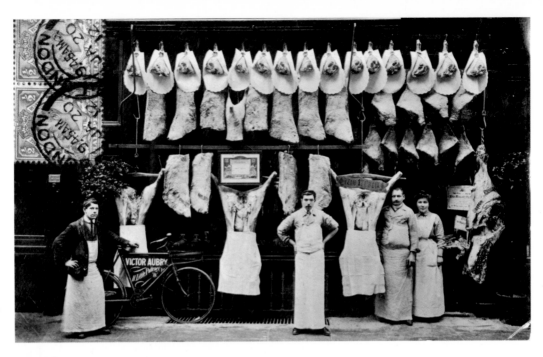

Victor Aubry, Butcher, No. 11 Little Pulteney Street (Brewer Street), *c.* 1910
Displays like this were commonplace among the butchers' shops of Edwardian London – here they include framed awards gained by the business for the excellence of its produce. Although there are fewer domestic stores like this in modern Brewer Street, a traditional French butcher's shop and Lina Stores, the continental grocers, are still here upholding this flavourful slice of Soho life.

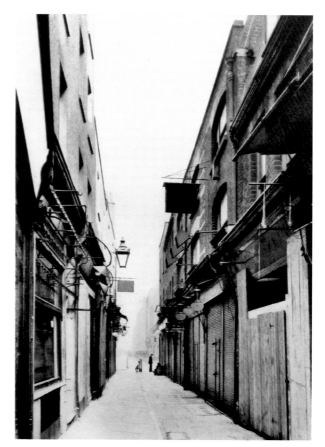

Walker's Court from Little Pulteney (Brewer) Street, *c.* **1920**
Now entirely devoted to entertainments of various kinds, this narrow passage was filled with domestic stores in Edwardian days – there was also an old cockney favourite, an eel pie shop. It all looked desolate when photographed, *c.* 1920, but in post-war years there was the noted Isow's Kosher Restaurant and a burgeoning night life, although as late as the 1950s a horse meat dealer still traded here. The arrival of the Raymond Revuebar in 1958 established Walker's Court as a centre for adult-themed diversions and a lively scene prevails today.

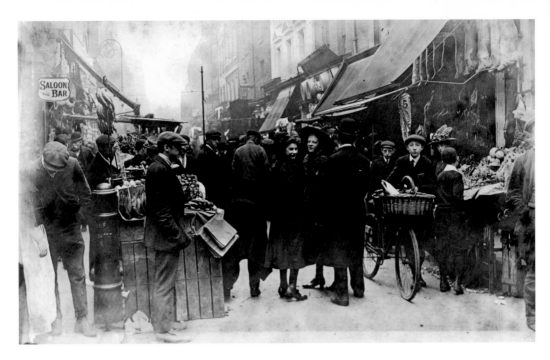

Berwick Street Market from Peter Street, c. 1908

This traditional market has eighteenth-century origins but it was the late Victorian era which saw it firmly established. It is seen here when busy with Christmas shoppers and when there were stalls on both sides of the road. Part of the City of London pub is on the left with St Luke's church (demolished 1935) just beyond it.

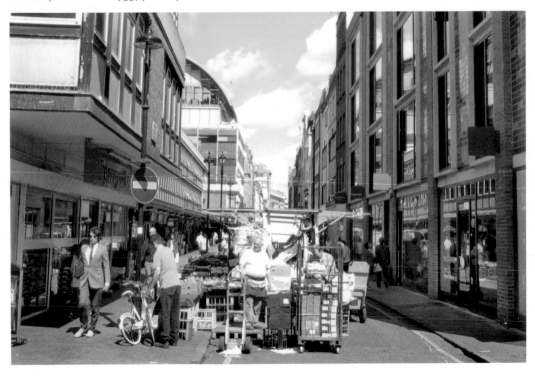

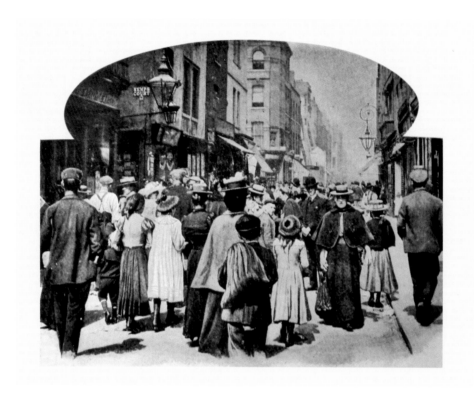

Sunday Morning in Berwick Street, *c.* 1896
Formerly the busiest day in the market was Saturday with shoppers lingering past midnight
and into Sunday morning. This busy scene is by Kemp's Court where the Hampshire Hog
pub adorned the corner. This is now the location of Soho's only residential tower block,
Kemp House, which was built for Westminster City Council from 1959–62.

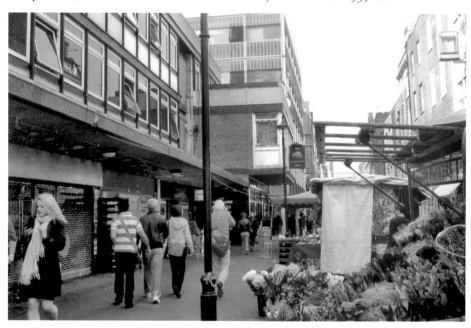

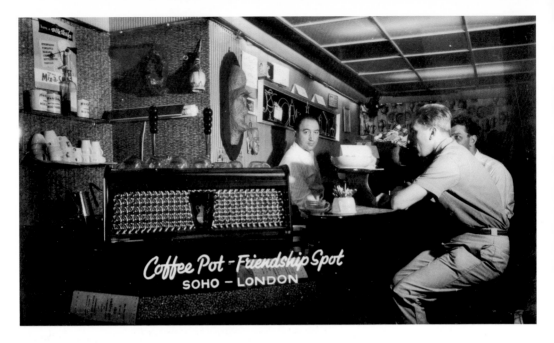

The Coffee Pot, No. 40 Berwick Street, 1960s

Often at the forefront of innovation, Soho hosted a new phenomenon in the 1950s with the advent of the coffee bar. These dispensed a new version of the beverage using impressive chromium espresso coffee machines from the Gaggia Company who were based locally in Dean Street. The first of the new breed was the Moka Bar in Frith Street while the Two I's in Old Compton Street was at the forefront of the emerging British Rock and Roll culture. Here at the Coffee Pot, the huge espresso machine stands ready for action.

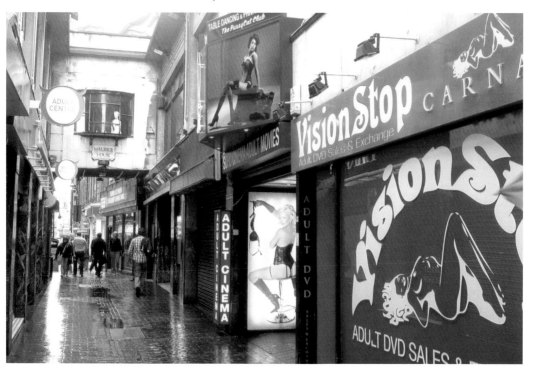

Book Shop and Strip Club, 1950s
Seekers of illicit pleasures have long been drawn to Soho but the reality was often found wanting. Here a murky doorway led to a basement strip show while the 'continental' bookshop next door had a typically drab look, albeit with the possibility of forbidden material lurking beneath the bookseller's counter. Sixty years on and the lights shine more brightly with licenced sex premises bringing a less furtive look to an old Soho industry.

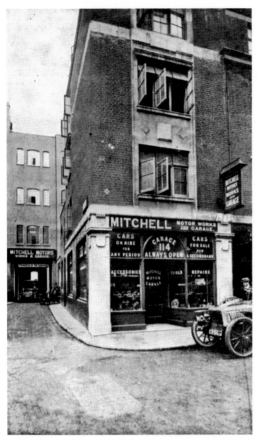

The Mitchell Motor Works & Garage, Wardour Street, *c.* 1912

In the 1500s Colemanhedge Lane ran through a rustic landscape but the late 1600s brought the beginnings of urbanisation and a new name, that of Edward Wardour, one of those who put up the first houses along the new street. As time passed, commercial interests began to colonise the houses, some of which were replaced by new buildings for the music trade and later by imposing offices for film companies. Less remembered is Wardour Street's part in the motor trade, but the Mitchall Motor Works was a major presence with a works for the manufacture and servicing of private cars and small commercial vehicles. The company had a small showroom in Wardour Street but the premises ran back into Ship Yard taking the whole of one side of Ship Alley (now Flaxman Court). The firm also operated hire, second hand and garaging services.

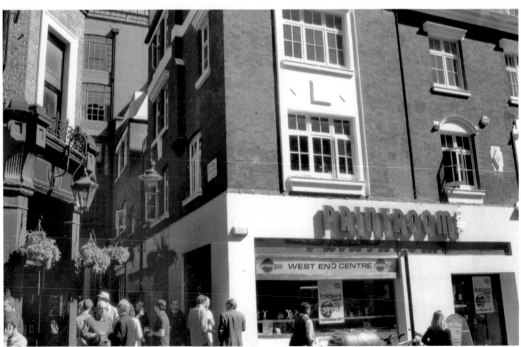

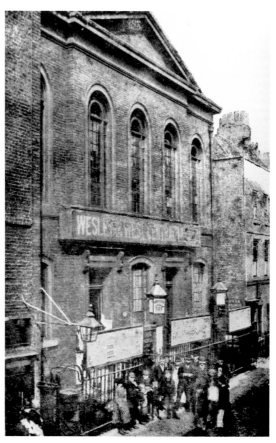

Wardour Hall, Little Chapel Street (Sheraton Street), *c.* **1893**

Huguenot refugees began worshipping here from around 1689 to 1784 after which their chapel was used by the Methodists. The building seen here was put up by Scottish Presbyterians in 1824, with the Wesleyans and their West Central Mission taking over in 1889. Demolition took place around 1894 after which the site was taken by music publishers Novello, Ewer & Co. for their printing and bookbinding works. The Novello family business had been in Soho since 1829 – 'Hymns Ancient & Modern' was an imprint of the company for the first time in 1860.

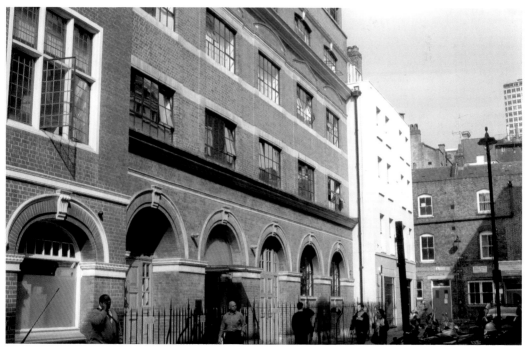

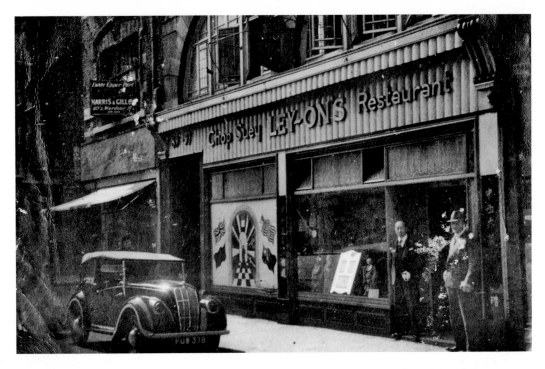

Ley-On's Chop Suey Restaurant, Wardour Street near Brewer Street, *c.* 1939
In the 1920s the flamboyant Ley-On, restaurateur and part-time film actor, unveiled his new venture in a street noted for the headquarter buildings of a variety of film-making companies. Although this was long before the rise of Soho's Chinatown, oriental cuisine was already popular, and Ley-On's prospered through the decades and became something of a favourite with visiting film stars.

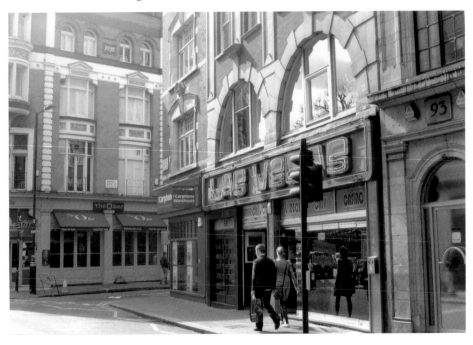

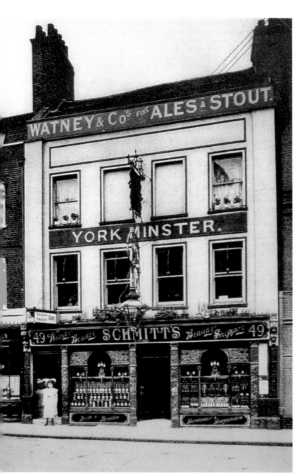
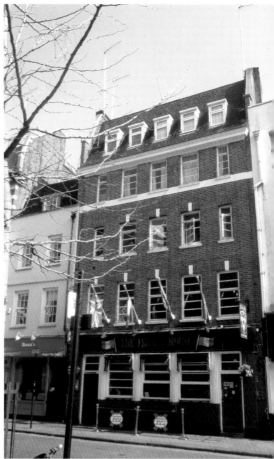

The York Minster (The French House), Dean Street, c. 1907

This old German house evolved into a famous French one when shortly before the First World War, landlord Christian Schmitt departed leaving the way clear for Victor Berlemont to take over. With a large local French population, the Gallic hospitality and atmosphere created by M. Berlemont gave the house a unique appeal which has endured into the present day. The old hostelry had a role to play during the Second World War when it was a focus of French resistance with Charles de Gaulle a frequent visitor. Victor's son Gaston took over the pub upon the death of his father in 1950, but the old traditions remained to attract the artists, writers and diverse Soho characters who gathered here. The old name 'York Minster' gradually fell out of use – it is known to everyone in Soho now as 'The French'. (Courtesy Maurice Friedman)

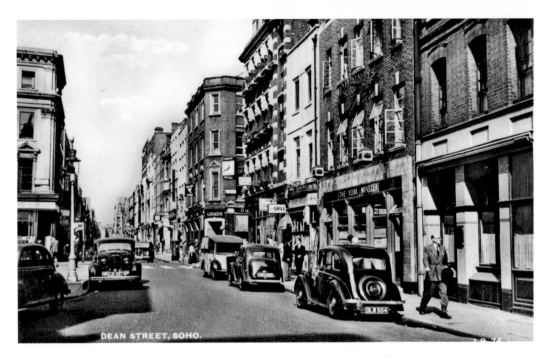

Dean Street by Romilly Street, 1950

Wartime scars have healed in part, and although the York Minster shows its new face, St Anne's church (off-camera left) was still in ruins. The Minella family's Café Torino (left) was an unpretentious port-of-call for a traditionally made cup of coffee in the days before the rise of the Gaggia machine.

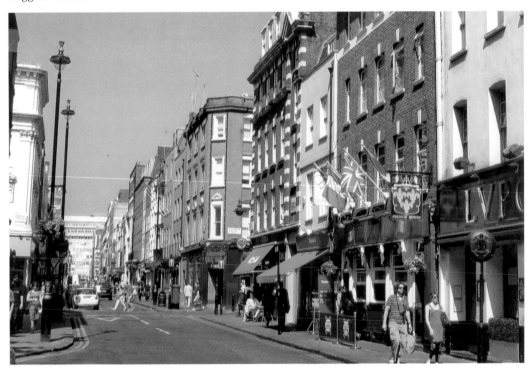

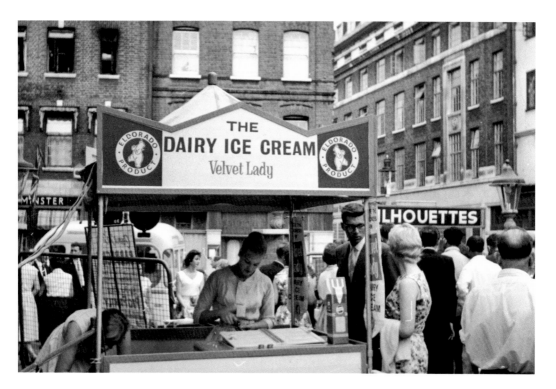

Ice Cream and Silhouettes, Soho Fair, Dean Street and St Anne's Church, 1958
Revived in 1955 under the French House's Gaston Berlemont and the Soho Association, the fair was a multi-day multinational celebration which included a street parade with floats reflecting aspects of Soho life. There were also stalls and displays on the partly cleared site of St Anne's church, and local glamour was promoted with a 'Miss Soho' event in Soho Square. The annual event continues as the Soho Festival.

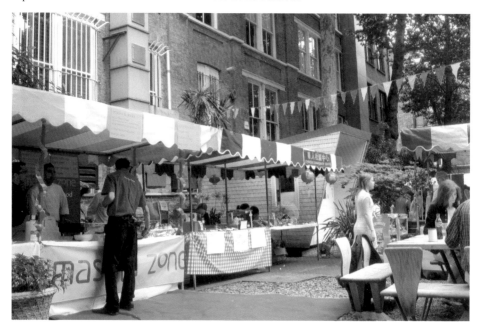

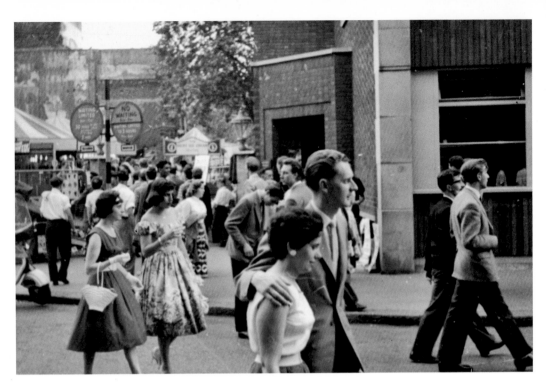

Soho Fair, St Anne's Church, Dean and Wardour Streets, 1958
Beyond the passersby in Dean Street, the old church site is seen with its stalls to contrast with the modern scene in St Anne's garden. The Soho Festival is now organised by the Soho Society, an enthusiastic community association founded in 1972 to conserve Soho's heritage and well being. The event itself combines elements of a traditional village fête with live music performances and sometimes a little of the outrageousness which characterises Soho.

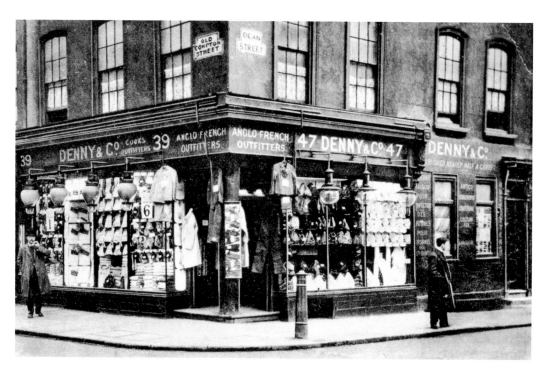

Percy Denny & Co., Hosiers, Old Compton Street and Dean Street, c. 1908
This long-standing local business had been established for 'nearly half a century' when pictured here in premises dating from around 1720. Specialising in uniforms and staff wear for the hotel and catering trades, Denny's remained on their corner following the rebuilding of the shop in 1923, but have since moved to one of the neo-Georgian buildings erected on the old bomb site of St Anne's church in Dean Street.

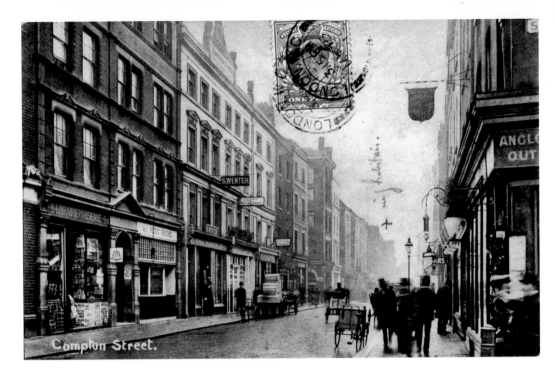

Old Compton Street by Dean Street, *c.* 1908

If Soho can claim to have a High Street, this would be it having always been at the heart of Soho life and a centre of the French community in the eighteenth and nineteenth centuries. The Gallic atmosphere remained in this Edwardian view with the Libraire Parisienne newsagents on the left and other continental businesses further along. Always a highly individual thoroughfare, Old Compton Street is now at the centre of London's gay community.

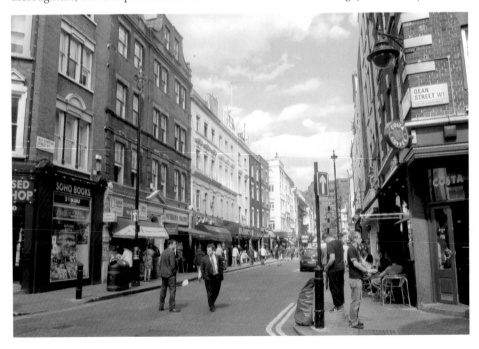

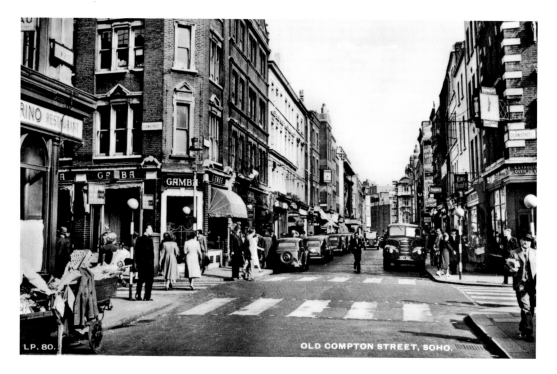

Old Compton Street by Dean Street, 1950

In this later image, many French shops had given way to Italian ones including the Café Torino by Dean Street and the long-established theatrical footwear and ballet shoe specialists, Gamba Ltd, opposite. To the right is the hanging sign for 'King Bomba', the Recchioni family's delicatessen. This famous emporium had long been noted for the high quality of the produce it imported from Italy – it is seen here in its final decade.

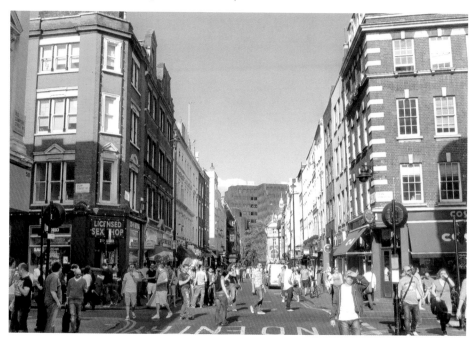

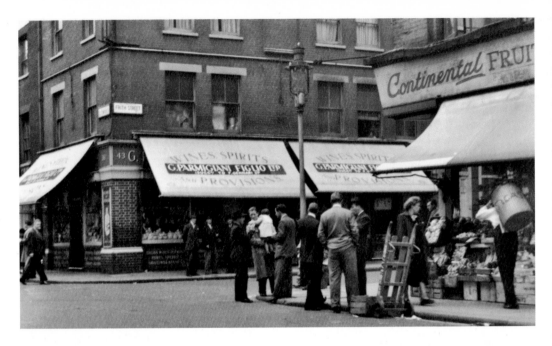

Old Compton Street by Frith Street, *c.* 1950

An informal shot of locals passing the time of day by the gas lamp on an old Soho corner. Vanished landmarks include the Continental Fruit Stores on the right with G. Parmigiani Figlio Ltd, the wine, spirit and provisions merchant, opposite. In the 1950s, Old Compton Street was as cosmopolitan as anywhere in London, yet the continental culture of the pavement café was still almost unknown in the capital – the modern image tells a different story.

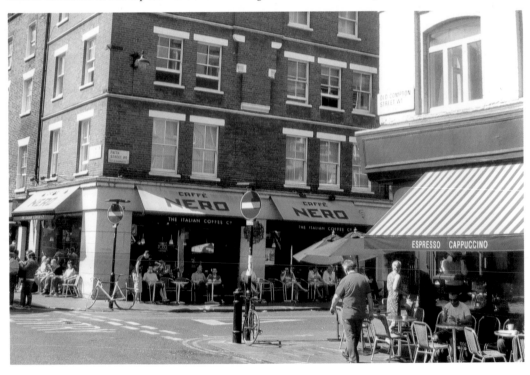

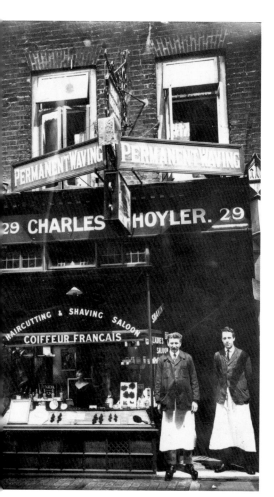
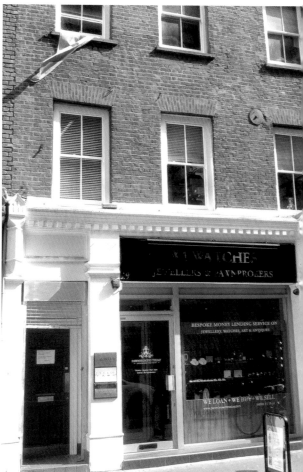

Charles Hoyler, Ladies and Gentlemen's Hairdresser, No. 29 Frith Street, *c.* 1924

A watchmaker traded here in Edwardian days but we see the shop when Charles Hoyler offered a variety of hairdressing services, including the permanent wave which had become popularised in the previous decade. The premises remained devoted to hairdressing into the 1940s, but with a change of direction they were reborn as the Charlotte Laundry. Fame was at hand, however, for this modest shop, and in 1953 Pino Riservato set up the Moka snack bar, the 'first café in England' to install the new technology of the Gaggia coffee machine. On a memorable Soho day, the premises were opened with much ceremony and considerable glamour by Italian film actress Gina Lollobrigida. The Moka ushered in the new era of the Soho coffee bar, but despite its new found trendiness, this was also an Italian snack bar serving traditional fare from that country. The Moka illuminated the Soho scene until 1972, after which the Queen's Snack Bar carried on the catering role here. Now, and after a lively century, the shop sells watches once more.

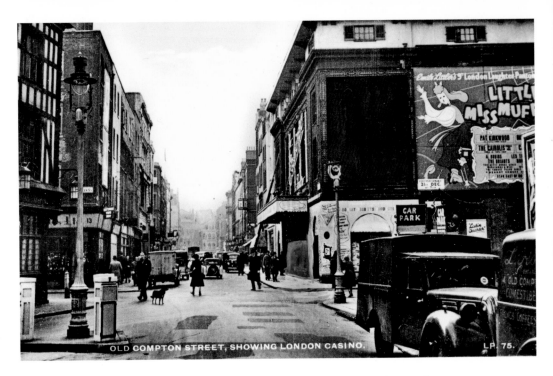

OLD COMPTON STREET, SHOWING LONDON CASINO. LP. 75.

The London Casino (Prince Edward Theatre), Old Compton Street by Greek Street, *c.* 1950
The theatre replaced a block of shops in 1930 and went on to enjoy a varied career as a cabaret-restaurant, live theatre and cinema – it also served as a club for servicemen in the 1940s. The casino was renowned from 1954 as the home of 'Cinerama', a giant curved screen which gave filmgoers a great sense of involvement. The building was reborn in 1978 under its original name, the Prince Edward Theatre – the first production was the long running stage musical *Evita*.

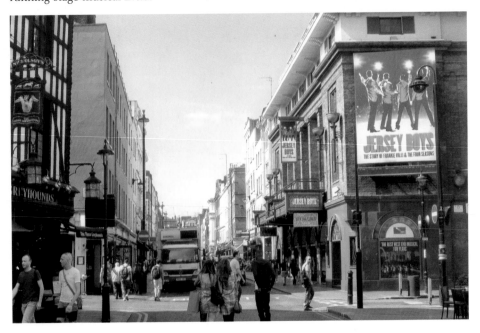

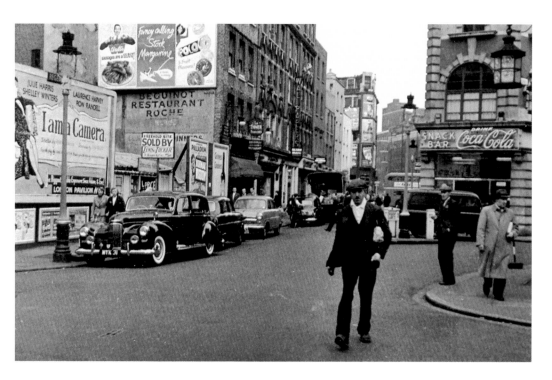

Old Compton Street by Greek Street, 1955

The Greek Street corner (left) was still marked by a wartime bomb site, but also some temporary huts which allowed traders to continue amid the hoardings – a café is seen here. To the right by Moor Street was Leslie's Snack Bar with its neon signs – it was housed in a remarkable building erected in 1904 and faced in green-glazed bricks. (Courtesy Allan Hailstone)

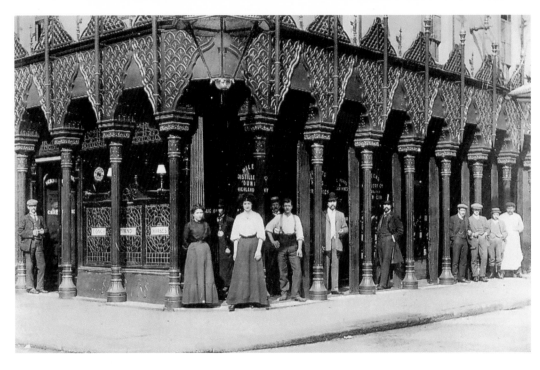

The Coach & Horses, Greek Street by Church Street (Romilly Street), *c. 1908*

The pub is justly proud of its antiquity having served Soho for over a century and a half. Victorian in style, the pub was remarkable for its decorative ironwork dating from 1889, elements of which remain today. In post-war years, the pub famously attracted a lively clientele of artists, actors and writers with legendary landlord Norman Balon at the helm. The modern image shows another great Soho institution, Maison Bertaux (1879), the oldest French patisserie in London. (Courtesy Maurice Friedman)

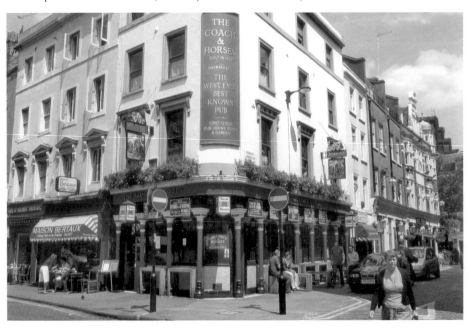

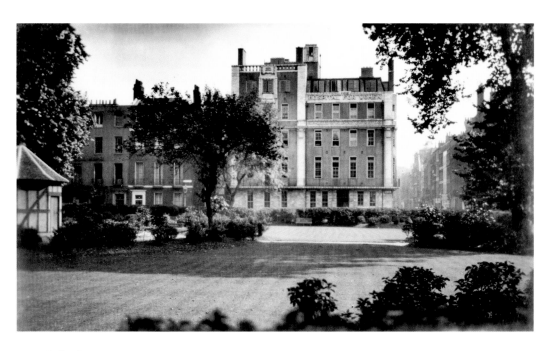

Soho Square, *c.* 1920

Soho Square arose as a smart residential address from 1677 but as the decades passed, many of its original houses made way for hospitals, churches and offices. The garden square is possibly the earliest in London but the seemingly medieval shelter is a twentieth-century creation. In the 1920s it was a modest hut for the square's gardeners – the genuinely ancient timbers were brought in from elsewhere as a later embellishment.

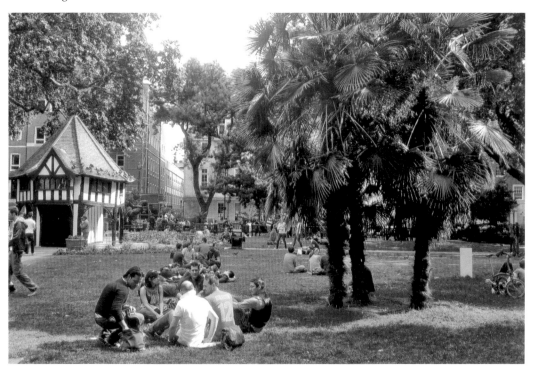

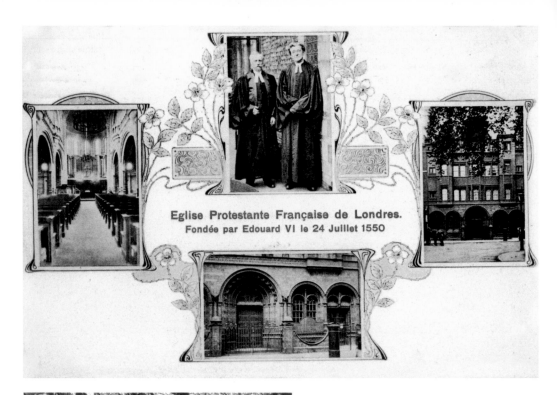

Eglise Protestante Française de Londres.
Fondée par Edouard VI le 24 Juillet 1550

The French Protestant Church, Soho
Square, c. 1905

French Protestant refugees, the
Huguenots, began settling in
London during the 1500s but in the
following century their numbers
increased considerably as Huguenot
communities developed in the then
new streets of Spitalfields and Soho.
The first Huguenot chapel in Soho
was in a building formerly used by
Greek Christians in Hog Lane (later
Crown Street and Charing Cross
Road), and as the French population
increased further, other chapels arose
in Berwick Street, Glasshouse Street
and elsewhere. The French Protestant
Church we see today was built in
1893 on a new site in Soho Square,
its architect, Aston Webb, designing
a sumptuous building with a richly
coloured brick and terracotta façade
– the church was dedicated on 25
March 1893. The date on this early
postcard image, 1550, refers to the first
Huguenot congregation in London,
which gathered at St Anthony's
Hospital in the City of London.

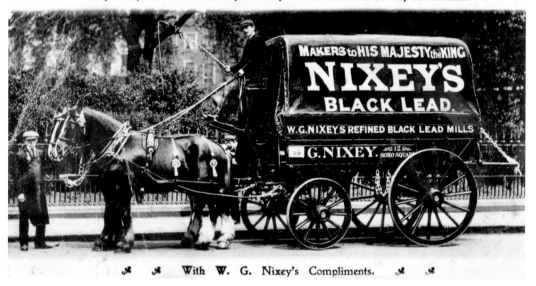

First Prize and Diploma for "Cleanliness" and Kind Treatment.
. . AWARDED TO CARMAN. . .
Thomas Crocker, in The Annual London Cart & Horse Show, Whit Monday, 1906, by
Lady Evelyn Ewart (of the Royal Society for Prevention of Cruelty to Animals.

MAKERS to HIS MAJESTY the KING
NIXEY'S
BLACK LEAD.
W. G. NIXEY'S REFINED BLACK LEAD MILLS
39 G. NIXEY SOHO SQUARE

⚜ ⚜ With W. G. Nixey's Compliments. ⚜ ⚜

W. G. Nixey, No.12 Soho Square, 1906
Soho Square's original houses were gradually eroded as new businesses moved in,
including that of W. G. Nixey who manufactured a range of essentials for the Victorian and
Edwardian household. These included knife powder, polish and black lead which was used
to smarten the grates of domestic coal fires. Nixey's once occupied an imposing old house
on the Soho Street corner but a modern block has replaced it.

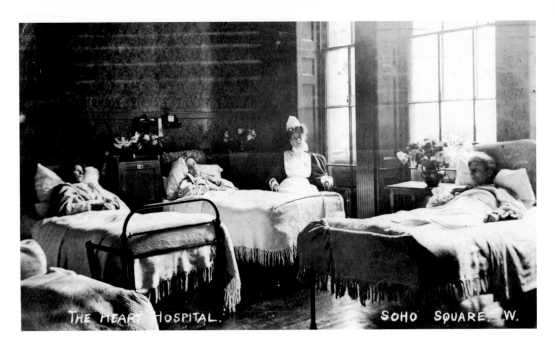

The National Hospital for Diseases of the Heart and Paralysis, No. 32 Soho Square, c. 1907
This was another of the specialist medical institutions to set up in Soho, and was established in 1874 in what had previously been the private house of naturalist Sir Joseph Banks (1743–1820). Here, patients rest under the watchful eye of Sister Elton in a ward created out of the house's former living quarters. The hospital moved to Westmoreland Street in 1914 and on to new premises in Fulham Road in 1991.

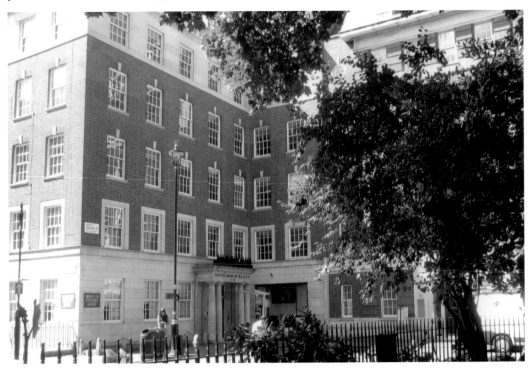

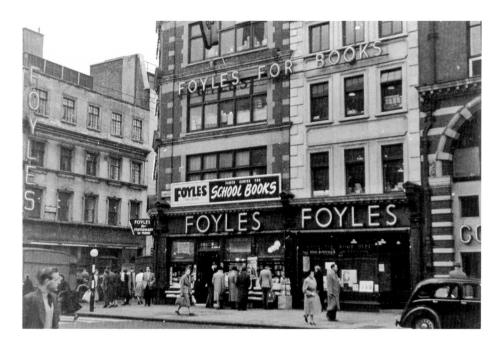

Foyle's, Charing Cross Road by Manette Street, 1955

When in 1904 William and Gilbert Foyle opened their first West End bookshop in Cecil Court, they could not have predicted that their venture would evolve into London's largest bookshop. They quickly made the move to Charing Cross Road, the premises seen here when they occupied both corners of Manette Street. The multi-level shop now takes up the whole of the further side of Manette Street and there are plans to move into even larger premises in Charing Cross Road – branches also flourish at the Royal Festival Hall, and elsewhere. (Courtesy Allan Hailstone)

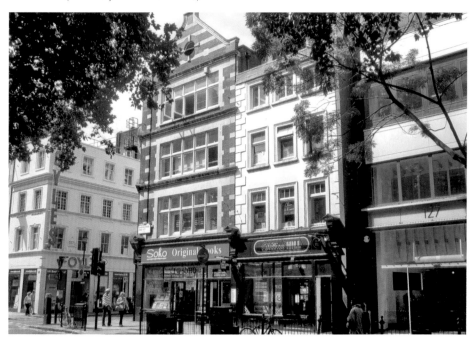

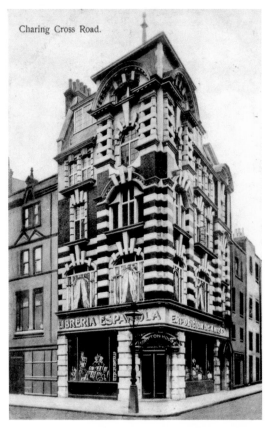

Charing Cross Road.

Libreria Española, Charing Cross Road by Old Compton Street, *c.* **1908**
The Libreria Española, which was housing an art exhibition when photographed, inhabited Compton House, an extraordinary building in Neo-English Baroque style by C. R. Worley (1907). Its green glazed brickwork and abundant bands stone still make an eye-catching spectacle but the matching shop front has been lost to a more modern design. A similar building can be found at the far end of the block by Moor Street. This northern section of Charing Cross Road was created out of old Crown Street in 1887 – the building to the right of the modern image is a surviving remnant of that long-lost street. A little of Old Compton Street is also seen with modern reconstructions of early buildings from the days when this part of the street was called Little Compton Street.

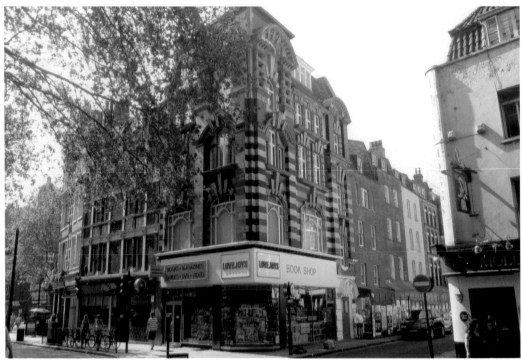

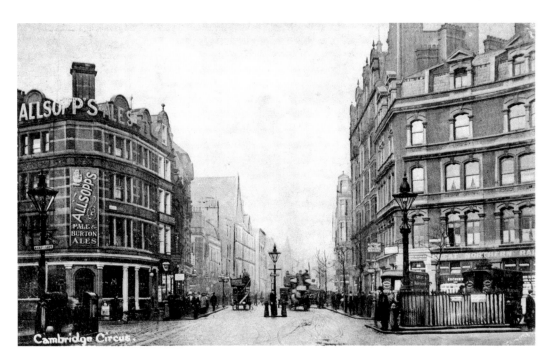

Charing Cross Road from Cambridge Circus, *c.* 1908
Cambridge Circus was created at the intersection of two new Victorian streets, Shaftesbury Avenue (1886) and Charing Cross Road (1887) – the older Moor Street also led into the circus. Here, the Cambridge pub displays some early electric signs in a street just twenty years old when photographed.

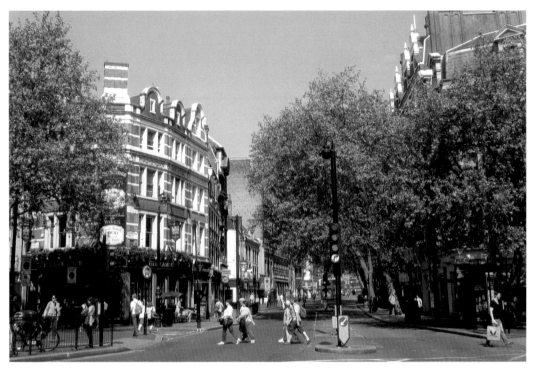

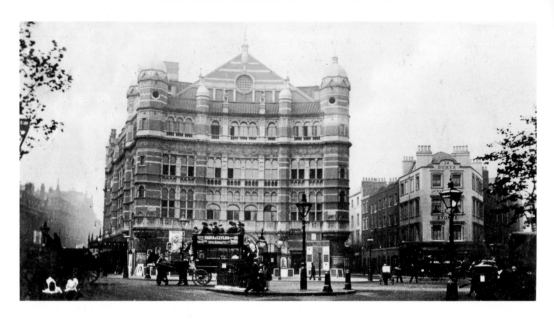

The Palace Theatre, Cambridge Circus, *c.* 1898

With its imposing concave frontage richly embellished in terracotta, the Palace spent the first year of its life as Richard D'Oyley Carte's Royal English Opera House – its first production was Sir Arthur Sullivan's *Ivanhoe* in 1891. In 1892, opera was discontinued in favour of Music Hall and Variety, and from 1919 there was a brief period in which the Palace was used as a cinema. Stage musicals were popular here from 1924 with post-war years seeing lengthy runs of *The Sound of Music* and *Jesus Christ Superstar* among others. The image pre-dates the arrival of the Spice of Life pub, right.

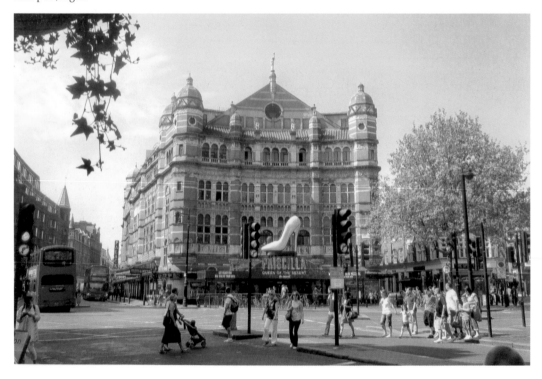

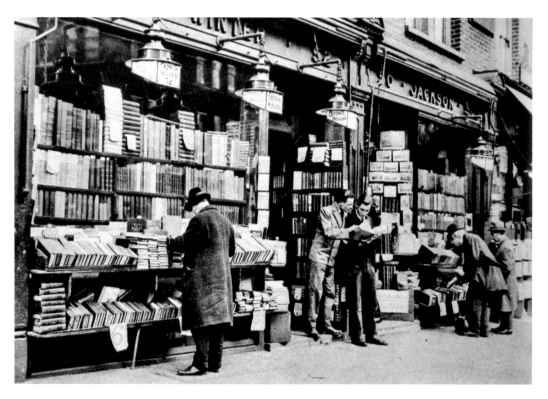

Charing Cross Road at Sandringham Buildings, c. 1935
Noted for its theatres and famed for its antiquarian bookshops, the southern section of Charing Cross Road was created along the course of the former Castle Street. The first of its trademark bookshops had already arrived by 1900 and were a considerable attraction for London's bibliophiles, as they are today.

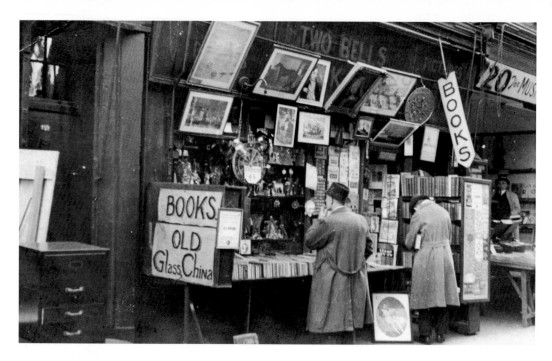

The Two Bells, No. 19 Newport Court, 1938

Second-hand booksellers Iris and Gatenby Bell presided over one of those fascinating emporia where household bric-à-brac, pictures, collectable stamps and much else competed for every inch of space both inside and outside the shop; neighbouring musical instrument dealer B. Rose also utilised the footway. These businesses were housed in two of Newport Court's late seventeenth-century buildings, but today all is Chinatown here – the large map of the Hong Kong Metro, left, enhances the Oriental atmosphere.

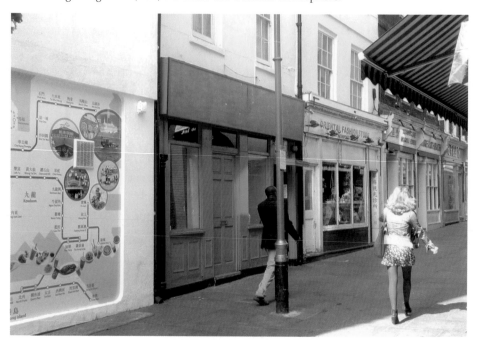

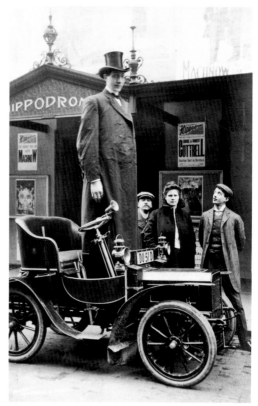

The Giant Machnow at the London Hippodrome, 1905

Opened in 1900 with designs by Frank Matcham, the London Hippodrome was created as a theatre for Music Hall and Circus. After 1912 it staged revues and variety shows with George Robey and Sophie Tucker among the notable performers to appear here. There was a change of direction in 1958 with reconstruction as a cabaret-restaurant, the Talk of the Town, which lasted until 1991. The early image pictures the Ukrainian giant Fyodor Makhnov, who was billed as 'Giant Machnow, the tallest man on earth'. His appearance at the Hippodrome in 1905 attracted much interest but Machnow apparently suffered severe homesickness for his Ukrainian homeland.

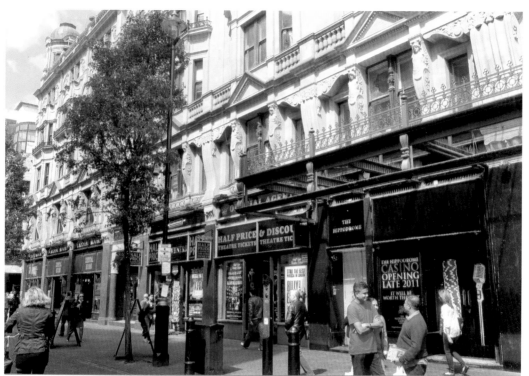

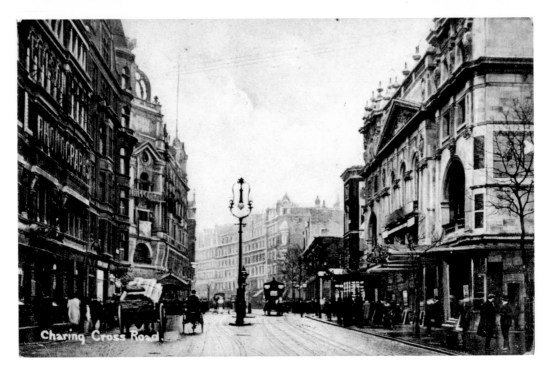

Charing Cross Road with Wyndham's Theatre and the London Hippodrome, *c.* **1908**
Wyndham's Theatre, right, was built in 1899 for actor-manager Charles Wyndham, and in over a century has enjoyed notable successes including over 2,000 performances of Sandy Wilson's *The Boy Friend* from 1953. Wall lettering, left, indicates the presence of the Edison Bell Consolidated Phonograph Co., makers of what was then a popular means of reproducing recorded sound from cylinders.

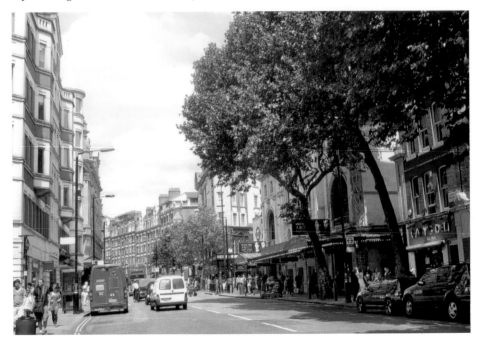

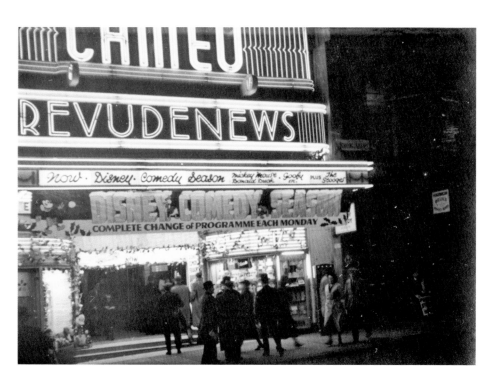

The Cameo Revudenews, Charing Cross Road by Bear Street, c. 1936

The cinema blazed with neon and modernity in the 1930s belying its ancestry as one of the West End's earlier picture houses. It set out in 1910 as the Cinema de Paris with its principal frontage in Bear Street, and, following a series of name changes, it emerged as seen here as a newsreel house. These were popular in the days before television news programmes, but further changes of name and direction followed before demolition ended a long life in 1989. Modern Cameo House preserves the name.

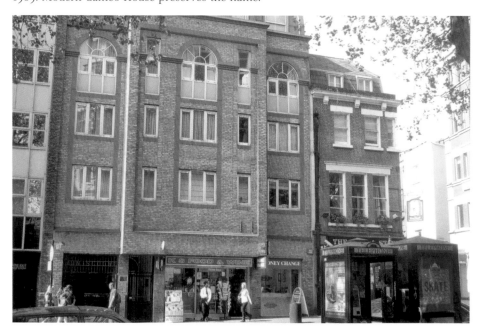

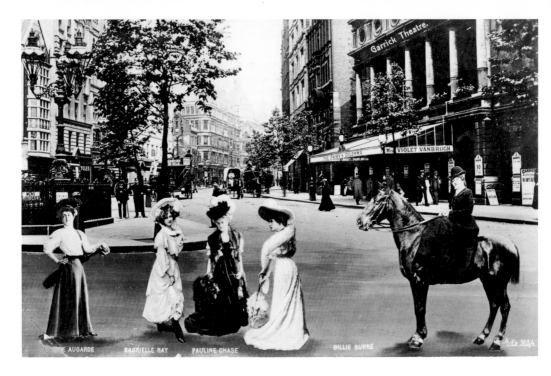

Edwardian Theatreland, Charing Cross Road, *c.* 1907

The newly built Charing Cross Road soon established itself as an important theatrical street in the West End, this view catching the Garrick Theatre (1889) with the London Hippodrome in the distance, but with Wyndham's just out of view and the Alhambra's rear entrance hidden by a tree, left. An inventive postcard publisher has superimposed (with no great skill) some popular stars of the Edwardian stage including Gabrielle Ray, Pauline Chase and Billie Burke – Violet Vanbrugh was appearing at the Garrick, right.

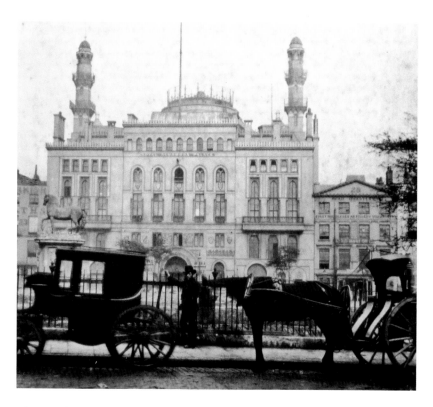

The Royal Alhambra Palace, Leicester Square, _c._ 1870

Leicester Square is at the epicentre of a world of entertainment but its early tradition of live theatre has given way to the later culture of the super-cinema. The Alhambra's Moorish architecture dominated the square since its earliest days as an exhibition hall in 1854, but with a series of reconstructions there were circus, music hall, ballet and stage shows to attract the West End's theatregoers. Closure in 1936 cost London a grand landmark, but another arose in its place, the Odeon Leicester Square with is great tower in polished black granite.

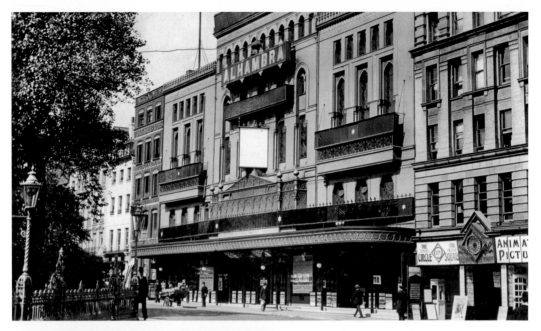

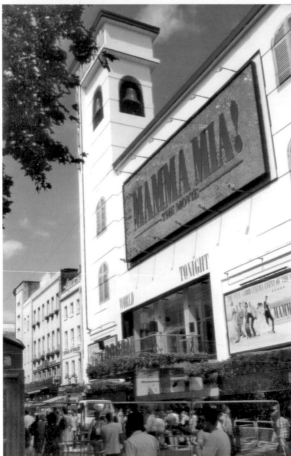

The Alhambra Theatre and the Circle in the Square Cinema, Leicester Square, *c.* 1912

The Alhambra continued to attract its audiences through the first decades of the 1900s but here in 1912 there were early signs of the entertainment revolution which would in time see the demise of Leicester Square's live theatres (including the Alhambra) in favour of cinemas. The Circle in the Square opened in 1909 and is seen here when its film programmes were still being advertised as 'animated pictures'. There was still life in the Alhambra, however, but it closed in 1936 to make way for the Odeon Leicester Square. The new cinema brought luxury and spectacular art deco embellishments in the auditorium and was ideally suited to host the array of glittering film premières which continue in the present day – the tower is seen in the modern image when transformed into an Italian campanile for the world première of *Mama Mia!* The Alhambra's further neighbour was Bartholomew's Turkish Baths, 'the largest in London'.

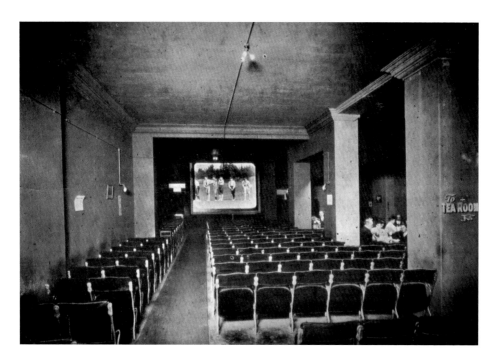

The Circle in the Square Cinema, Leicester Square, c. 1910

A glimpse inside this early movie house where in contrast to the luxurious West End cinemas of the present day there were hard seats, bare light bulbs and unadorned walls awaiting the first audiences; there was, however, a tea room. Despite these discomforts, the cinema endured through a series of name changes ('Cupids' in 1914 and 'Palm Court Cinema' in 1926) until 1928 when its silent films proved no match for the new 'talkies' being shown across the road at the Empire. A little of the old façade can still be seen.

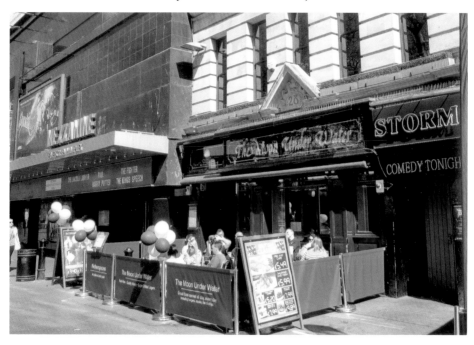

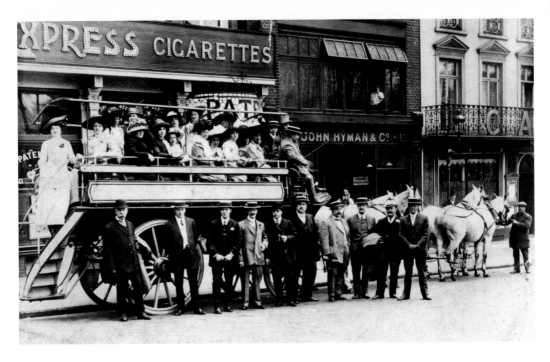

Theatregoers in Leicester Square, *c.* 1906
The sight of coach parties of theatregoers is a familiar one in the West End, but in Edwardian London a horse brake or charabanc may have been used. The background here shows more of Leicester Square's pleasure spots including the Hotel Cavour, right, and Hotel Provence, left, where some post-theatre supper might have been taken. Theatrical costumiers John Hyman & Co. sat between them.

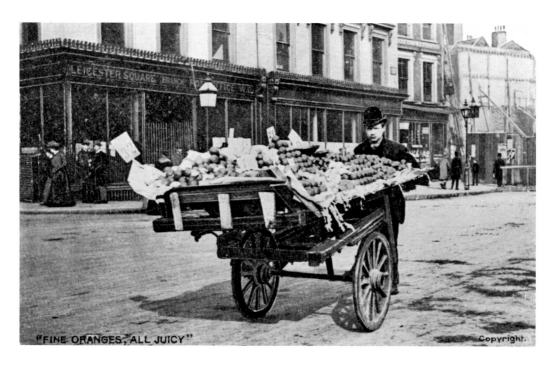

"FINE ORANGES, ALL JUICY" Copyright.

An Orange Seller, Leicester Square, *c.* 1892

This is the modern haunt of buskers, caricaturists and souvenir sellers, but in the 1890s this gentleman earned a living selling fruit. The background is Leicester Square's long-lost post office, the future site of the Hotel et Grand Café de l'Europe (1899), while further along, an empty site awaited the building of Daly's Theatre (1895).

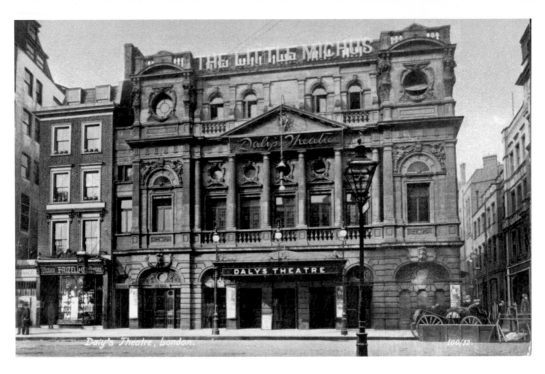

Daly's Theatre, Cranbourn Street, Leicester Square, 1905

Built for the American Augustine Daly, the theatre was noted for the musicals it staged throughout its life. Demolition in 1937 was followed by the erection of the Warner, a new super-cinema. It lives on today as part of the Vue chain, but its striking wall plaques by Bainbridge Copnall still offer a 1930s vision of the spirit of sight and sound. Also surviving and pre-dating both the theatre and the cinema is the single building on the left. Now 'Bella Italia', it housed Frizell & Co. chemists in 1905.

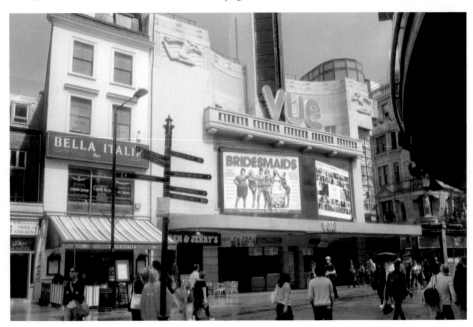

Outdoor Entertainments, Leicester Square, 1940s
While Leicester Squares theatres and cinemas have long attracted the crowds, an additional culture of buskers and other entertainers developed to work the queues. Leicester Square's garden has also been utilised for events and stage shows, while in a recent promotion, a piano was set up in the gardens for passersby to show off their skills – the illustrated act was more ambitious than most.

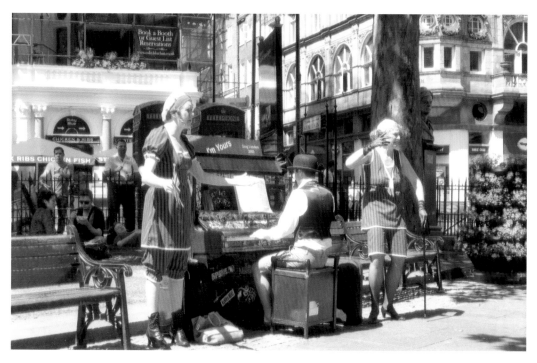

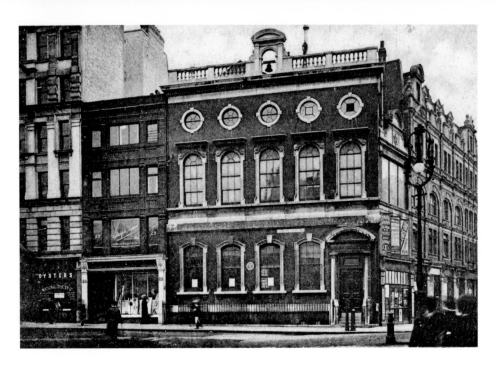

Archbishop Tenison's School, Leicester Square by Green Street (Irving Street), *c.* 1908
From the 1670s, long before the arrival of its entertainments, Leicester Square was a fashionable residential address, and among those attracted here was engraver William Hogarth who occupied a house from 1733 to 1764. Archbishop Tenison's School was built on the site of Hogarth's house in 1870 before moving away to Kennington in 1928. A new building arose in the 1950s and was refronted in 1997 – it is now the home of Global Radio and houses a number of London's commercial radio stations.

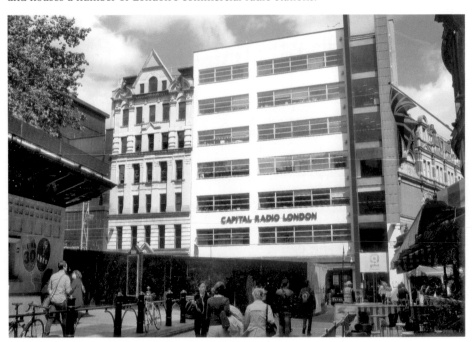

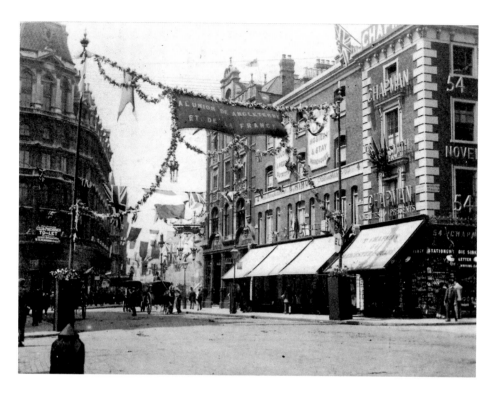

New Coventry Street from Leicester Square, 1904

A block of buildings which included the Leicester Hotel, the shop of George Himis, ladies' outfitter and Thomas Chapman, stationer, is seen before road widening and the erection of the Swiss Centre in 1966 transformed the street. The demise of the Swiss Centre was followed in 2011 by a new landmark, the glassy W Hotel and the M&M's World store. Street decorations here are for the visit to London by President Loubet of France.

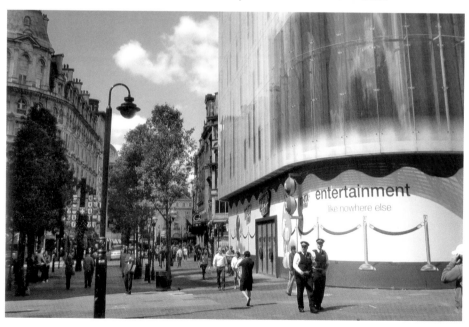

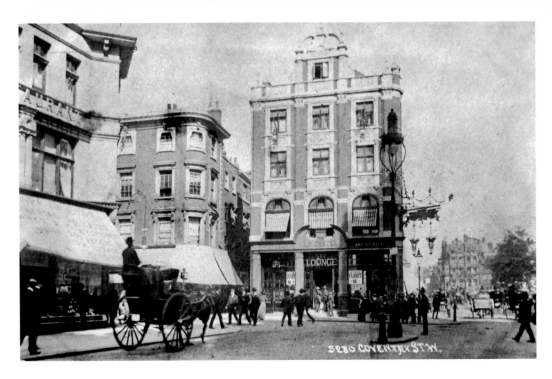

The Leicester Hotel from Coventry Street, *c.* 1906
The Victorian frontage of the Leicester Hotel is seen with Sidney Place, the narrow alley which separated it from Horace Russell's, the ladies' outfitters in Wardour Street. The arrival and departure of the Swiss Centre occurred in the time span between the images, but an old inn sign containing the arms of twenty-six Swiss Cantons remains in place.

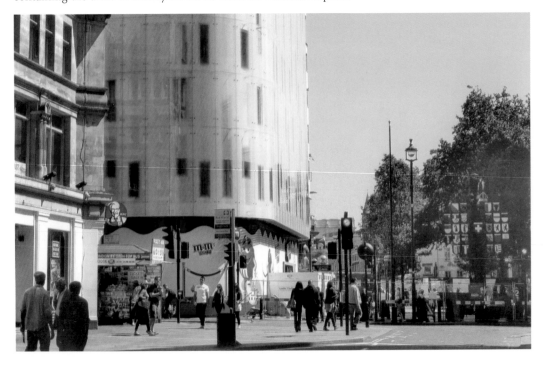

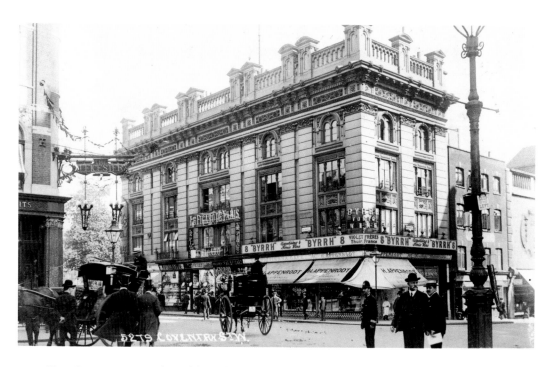

New Coventry Street by Whitcomb Street, *c.* 1907

There was a strong continental flavour here with Violet Frères, suppliers of Byrrh Tonic Wine on the corner alongside Herman Appenrodt, provisions merchant and the Vienna Café. Their neighbour was the Librairie du Figaro, a continental newspaper shop with the offices of Le Figaro du Paris upstairs. The block was replaced in three stages between 1937 and 1959 by the Automobile Association's Fanum House.

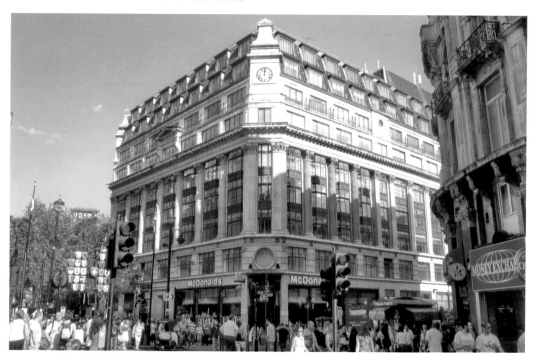

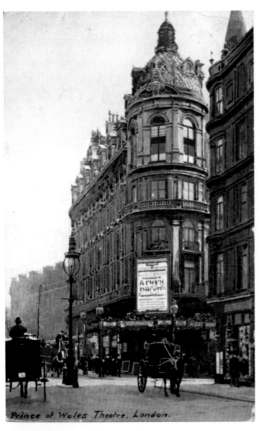

Prince of Wales Theatre, London.

The Prince of Wales Theatre, Coventry Street, c. 1907

Coventry Street existed from around 1681 and was lined with town houses but a proliferation of gaming houses gave the neighbourhood something of a reputation. The street became devoted to shopping and dining following the enlargement of Piccadilly Circus in 1886 and evolved into an important link between the entertainment districts running up to Leicester Square. Further restaurants and refreshment houses blossomed including a J. Lyon's Corner House which seated over 4,000 diners. Coventry Street also had its own theatre, the Prince of Wales, which opened in 1884 – it was rebuilt in art deco style in 1937. Since then the theatre has enjoyed long runs of *South Pacific* and *Aspects of Love* with *Mama Mia!* the current attraction.

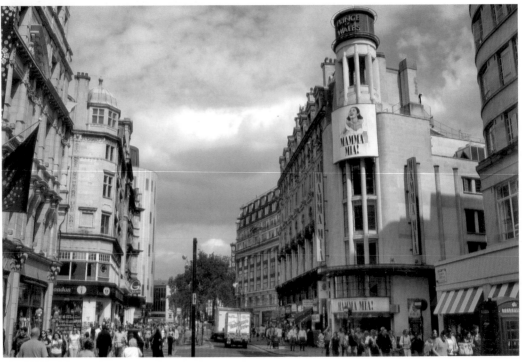

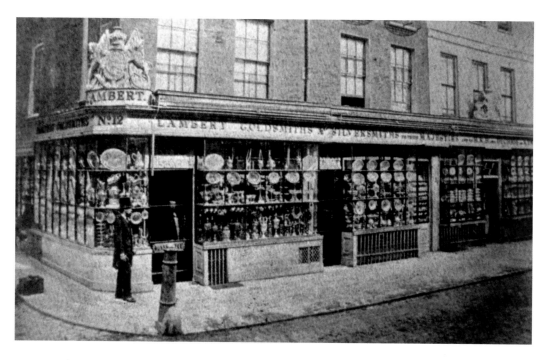

Lambert & Co., Coventry Street by Arundell Street, c. 1865

Gold and silversmiths abounded in nineteenth-century Soho and among them was Messrs. Lambert (founded 1803) who proudly displayed their Royal Warrant. The premises had fine Georgian shop windows with small glass panes, and although the fashion for large plate glass windows drove the earlier style to virtual extinction, Lambert's retained theirs until the premises were demolished in 1914. Also lost then was Arundell Street, left, and tiny Panton Square which lay at the end of it. The London Trocadero is here now.

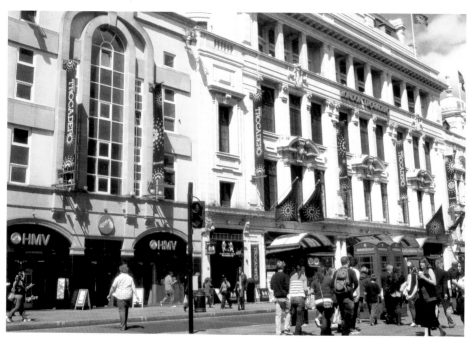

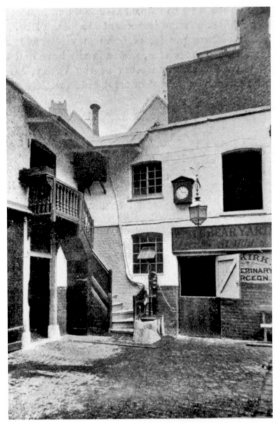

White Bear Yard, No. 25a Lisle Street, c. 1895

A hidden backwater in Victorian Soho, this aged remnant of former times was reputed to have once formed part of the stable complex of Leicester House (1635). This was the grand mansion of the 2nd Earl of Leicester – it was one of London's largest houses and lasted until 1792. The decorative wooden stairway hints at opulence not normally seen in a working yard like this, but at ground level the businesses were devoted to the horse. These included William Dunscombe's livery stables and veterinary surgeon William Kirk – an old hand pump is seen outside his premises. White Bear Yard was reached through an archway from Lisle Street which can still be seen – it is now part the Imperial China restaurant seen in the middle of the modern image.

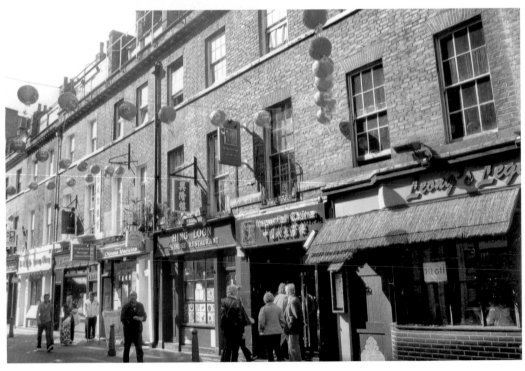

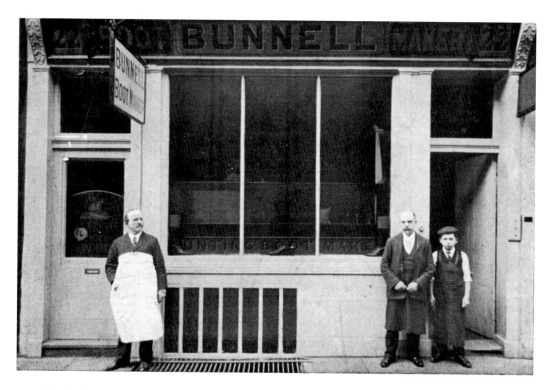

Benjamin Bunnell, Bootmaker, No. 22 Lisle Street, *c.* 1920
Lisle Street's long terrace is from the 1790s and in former times it was mostly devoted refreshment houses and the workshops of specialist craftsmen including Benjamin Bennell, who had just moved in. With its smoke-blackened brickwork the street looked drab in post-war years, but as the Chinese community took hold, everything brightened up with a vibrant street life and colourful oriental restaurants and supermarkets.

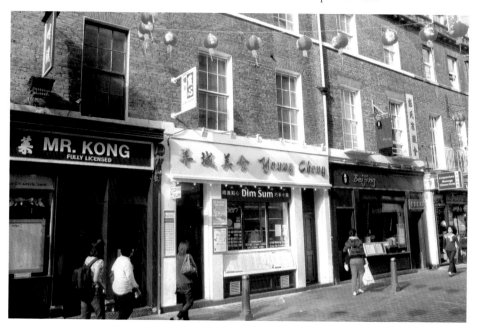

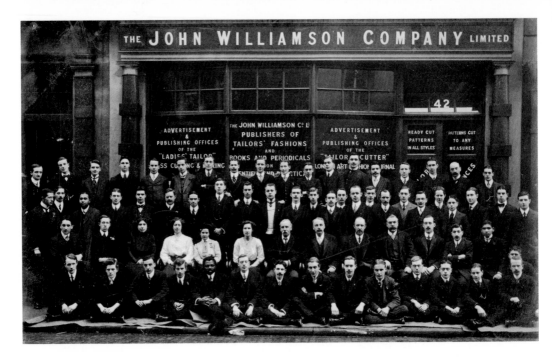

The John Williamson Company Ltd, No. 42 Gerrard Street, c. 1908

This firm published books and periodicals for the tailoring trade, the stiff formality of the company's group photograph contrasting with the scene a century later and the bustle of a Chinese supermarket. This transformation was typical of Gerrard Street, as old specialist businesses including silversmiths, watchmakers and continental restaurants made way for the new world of Soho's Chinatown. A wall plaque honours poet and dramatist John Dryden (1631–1700), who lived nearby.

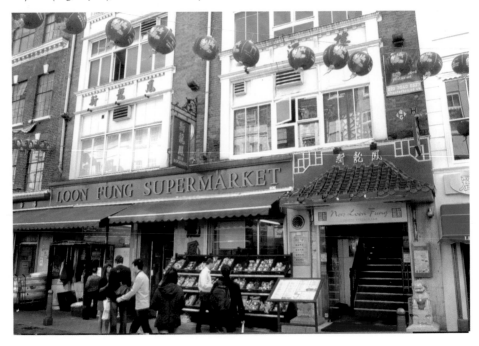

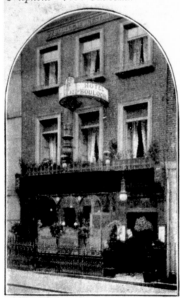

Telephone — 7464 CENTRAL.

Telegrams — UCCELLETTO, LONDON.

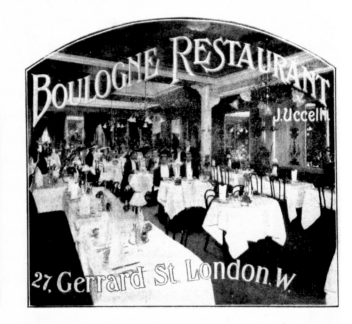

Hotel de Boulogne, No. 27 Gerrard Street, *c.* 1904

Opened in 1874 by Frenchman Philippe Ganosse, the hotel gained Italian management early in the twentieth century when Joseph Uccelli took over. Further Italian proprietors continued the tradition of continental dining, and there were banqueting rooms for weddings and regimental dinners. The Boulogne endured long into post-war years, but with the 1970s came Chinatown and the colourful chinoiserie of modern Gerrard Street.

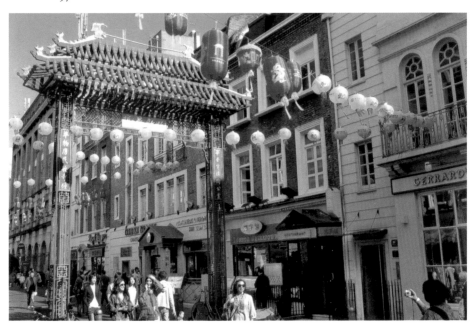

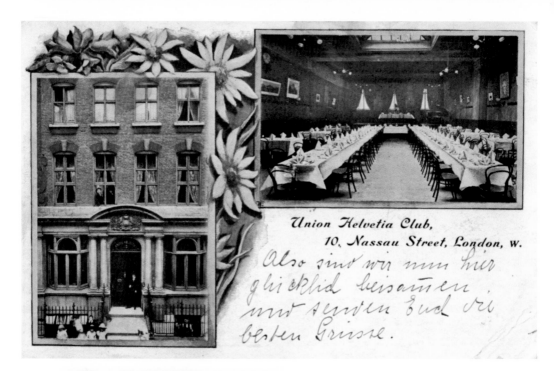

Union Helvetia Club,
10, Nassau Street, London, W.

Also sind wir nun hier
glücklich beisammen
und senden Euch die
besten Grüsse.

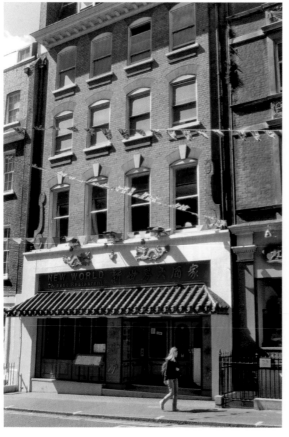

Union Helvetia Club, Nassau Street (Gerrard Place), *c.* **1903**
Soho's plethora of continental restaurants and hotels required a substantial workforce of waiters, chefs, and others to ensure smooth running. Much of the staff was also of continental origin, working in what was for many an unfamiliar city in a distant land. Swiss nationals were employed in some quantity in Soho and Fitzrovia, and for them a number of organisations provided hostels, union facilities and social clubs for fellow countrymen. One such was the Geneva Association in Shaftesbury Avenue, while the Union Helvetia Club in Nassau Street was a Swiss Hotel Employee's Society. This also had spacious dining facilities – the building can still be seen in a new guise as a Chinese restaurant.

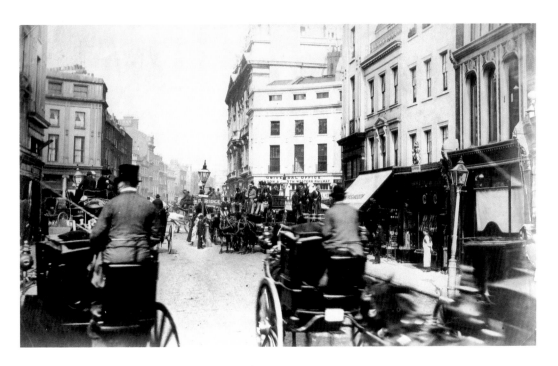

Regent Circus South (Piccadilly Circus), *c.* 1880

John Nash's grand new Regent Street opened in 1819 meeting the older Piccadilly at a crossroads which Nash stylishly laid out as a circus of equally sized quadrants. The greatly enlarged circus we know today came about in 1885 with the demolition of the north-eastern quadrant, left, for the new Shaftesbury Avenue and a rebuilt London Pavilion music hall. The image shows the tiny scale of the original circus, similar to that of Oxford Circus – the Criterion is the sole survivor. (Courtesy Janette Rosing)

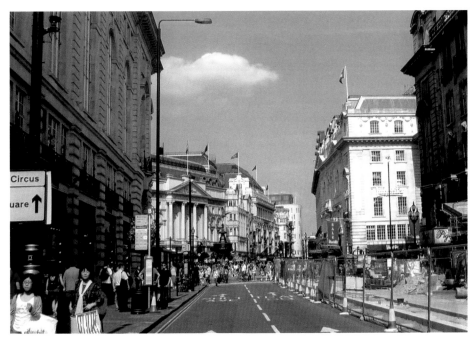

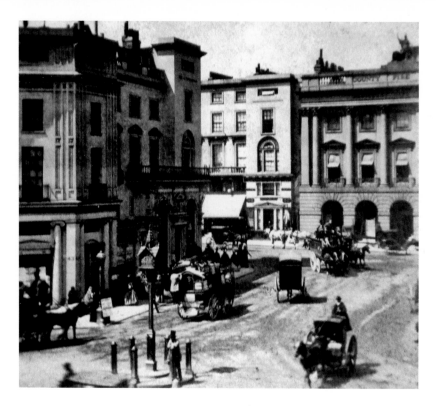

Piccadilly Circus Lights, *c.* **1870 and** *c.* **1920**

Piccadilly Circus's electric advertising signs provide a spectacle known worldwide, the first of them originating around 1893 as sky signs along the rooftops of old Tichborne Street, now Glasshouse Street. Here an historic image shows something earlier still, possibly the first of the circus's illuminated advertisements. It is in the form of a column topped by an ornate gas-lit lantern highlighting the premises of the Submarine Telegraph Company at what was then No. 43 Regent Street, the future Swan & Edgar site. The 1920s image shows one of the brilliant displays provided by incandescent electric lights before neon brought a new style for the 1930s.

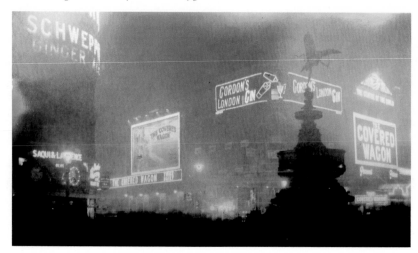

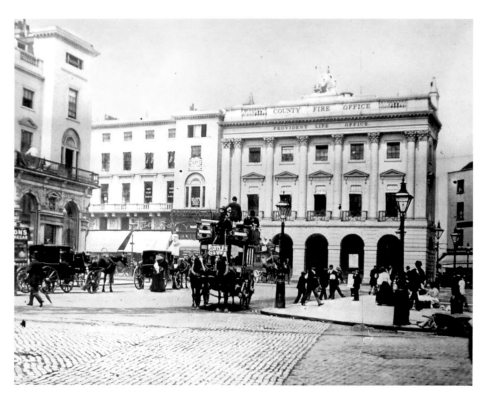

Regent Street and the County Fire Office, Piccadilly Circus, *c.* 1895
Nash's stucco-faced Regent Street was a study in nineteenth-century elegance, but a new century would bring about the loss of all of it in favour of the grander stone-fronted buildings we see today. The street's rebuilding was deemed complete by 1927, the year in which the new County Fire Office was finished.

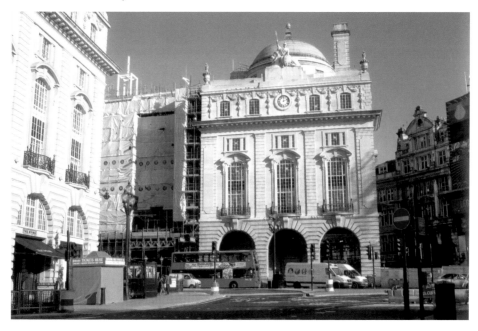

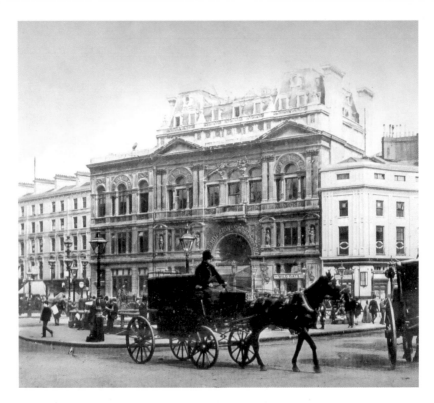

The Criterion Restaurant and Theatre, Piccadilly Circus, *c.* 1895
Opened in 1874 by the popular Victorian caterers Spiers & Pond, the restaurant was joined in 1875 by the theatre which was unusually located in the basement. The photographs show how a grander style of architecture was beginning to replace the plainer designs of old residential Piccadilly, and how the Criterion had gained a more prominent position in the street by the enlargement of Piccadilly Circus in the 1880s.

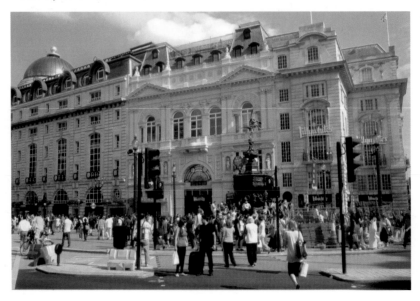

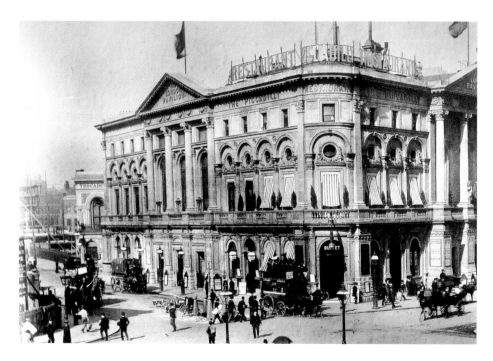

The London Pavilion and Shaftesbury Avenue from Piccadilly Circus, *c.* 1887
This new thoroughfare cut through old Soho streets on its way to New Oxford Street and is seen here when still far from complete – Piccadilly Mansions, far left, and Avenue Mansions (1889) had yet to appear. The 'first stone in the new street' had been laid in 1885 at the rebuilt London Pavilion, right, but the Trocadero Music Hall (1820, rebuilt 1882) stood until demolition cleared the way for J. Lyons & Company's Trocadero Restaurant in 1896. (Courtesy Janette Rosing)

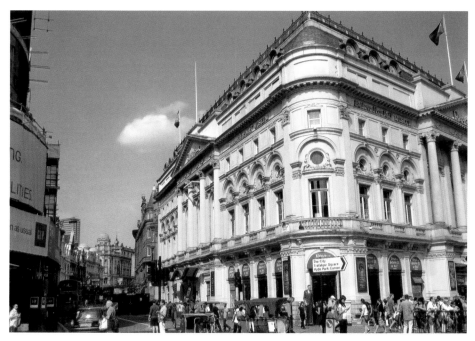

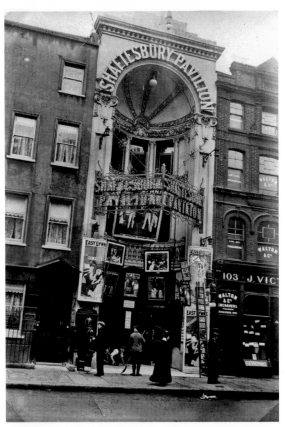

The Shaftesbury Pavilion, Shaftesbury Avenue

This 150-seater cinema opened in 1912, the narrow entrance leading to an auditorium behind the houses – facilities included a pipe organ to accompany the silent films. A change of direction carne in 1930 when the cinema was remodelled as the G. B. Movietone News Theatre, this country's first newsreel cinema. In 1939 it was the Gaumont News Theatre but it all ended when the Blitz wrecked the building. A new office building, Wingate House, opened on the site in 1959 with the Columbia (later Curzon) cinema in the basement. The houses on the left of the earlier photograph were once part of King Street, an old Soho street consumed by the building of the new Shaftesbury Avenue in the 1880s. (Courtesy Maurice Friedman)

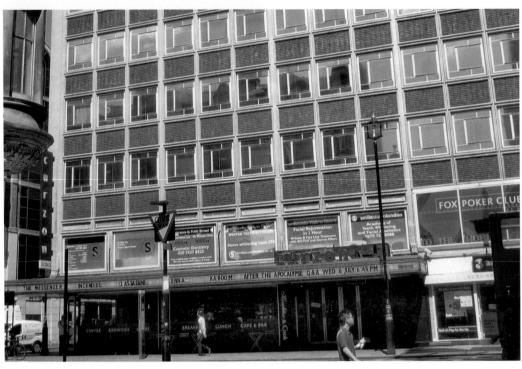

The Shaftesbury Theatre, Shaftesbury Avenue by Gerrard Place, 1909

The newly opened Shaftesbury Avenue soon gained a character of its own through the remarkable sequence of theatres which grew up along it. The Shaftesbury was, in 1888, among the earliest to open – the opening production was *As You Like It* with Forbes-Robertson. The theatre was photographed here while enjoying a lengthy run of the musical play *The Arcadians*, but the building was destroyed in 1941 by wartime bombing. The site was later taken by Soho Fire Station, which had previously occupied an adjacent location following its removal from Great Marlborough Street. Having been lost to Theatreland for a couple of decades, the name 'Shaftesbury Theatre' re-emerged in 1962 when it was adopted by the old Prince's Theatre at the Holborn end of Shaftesbury Avenue following reconstruction.

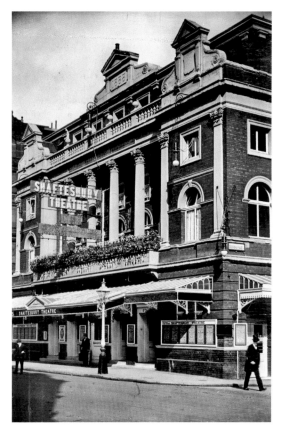

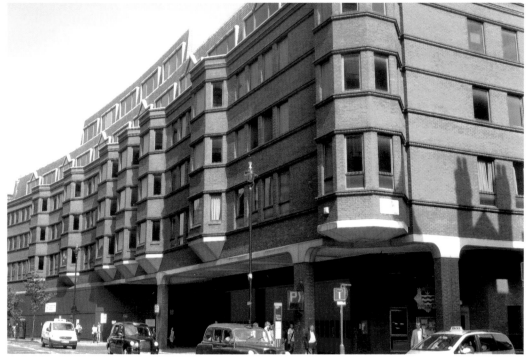

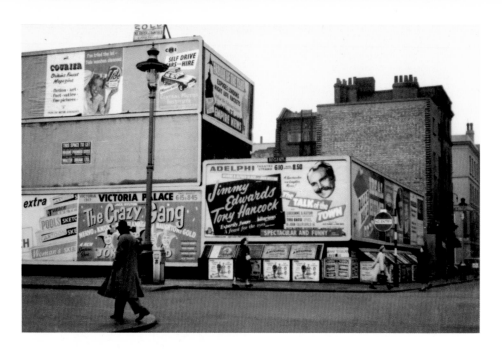

Bomb Site, Shaftesbury Avenue by Greek Street, *c.* 1954

The bomb which destroyed the Shaftesbury also wrecked the buildings opposite, the bomb site lingering on for over two decades. Advertising hoardings hid some of the unsightliness, with the posters highlighting some of London's entertainment options. These included The Crazy Gang, who appeared at the Victoria Palace from 1947–62, and the Talk of the Town revue starring Jimmy Edwards and Tony Hancock, which enjoyed a run at the Adelphi from November 1954 to October 1955. There were also advertisements for two now lost newspapers: *The Sketch* (1953–71) and *Empire News* which merged with the *News of the World* in 1960.

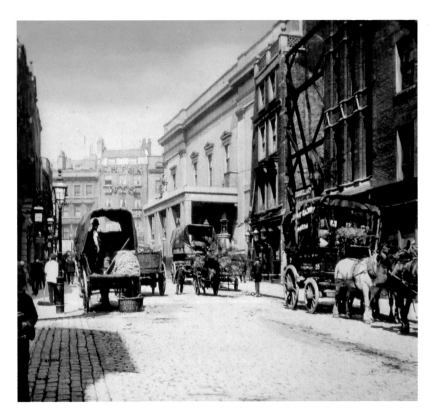

Catherine Street and the Theatre Royal Drury Lane, *c.* 1890
The wider area of London's Theatreland takes in Covent Garden and includes Catherine Street and Drury Lane where a theatre has stood since 1635. Actress and mistress of Charles II, Nell Gwyn performed at the theatre put up here in 1663, while further rebuilding by Christopher Wren and Robert Adam culminated in the present building of 1812 by Benjamin Wyatt. The photograph shows how Catherine Street was enlivened by the activities around Covent Garden Market.

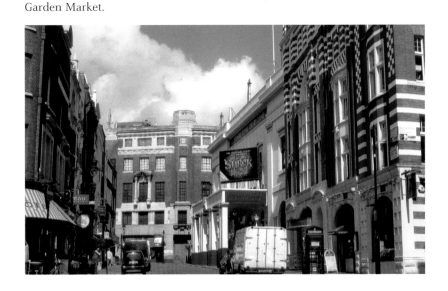

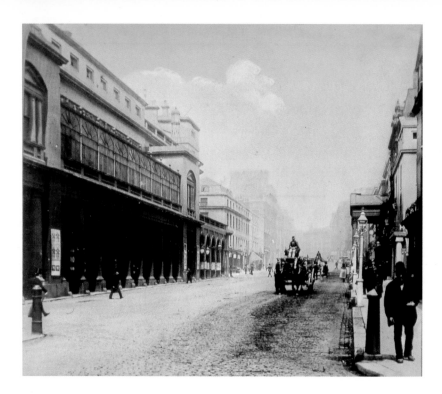

Her Majesty's Theatre, Haymarket, *c.* **1890**

The first theatre here was the Queen's (1705), which was rebuilt as an opera house in 1791 becoming the largest theatre in England. The colonnade was added in 1818 and in 1878 Bizet's 'Carmen' was staged for the first time in England. Rebuilding in 1897 brought the familiar theatre of the present day, part of a matching pair with the Carlton Hotel on the Pall Mall corner; unfortunately the latter was replaced by the visually disastrous New Zealand House from 1957–63. Both images catch the portico of the Theatre Royal, right, which originated in 1720 as the Haymarket Theatre. It was rebuilt by Nash in 1821.

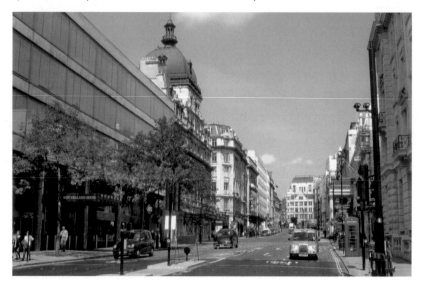

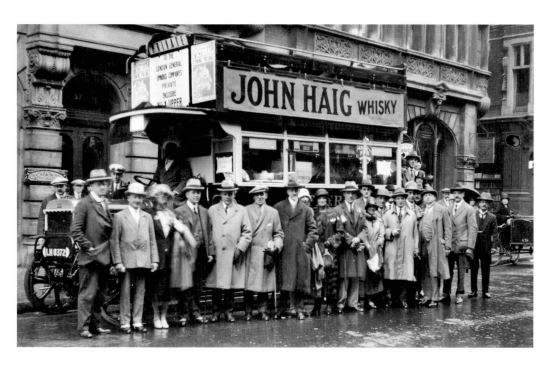

Bus Trips, St Martin's Lane by Cecil Court, *c.* 1922

This was the principal north/south route before Charing Cross Road opened in the 1880s – it has long been noted for the theatres which adorn it. This, however, is not a party of theatregoers but one bound for Epsom and the Derby. Their bus is parked by Cecil Court, a pedestrian byway long distinguished by its picturesque assembly of book and collectors' shops – that of bookseller Thomas Thorp is on the far right. In the 1910s, Cecil Court was the base for so much of the British film trade it was styled 'Flicker Alley'.

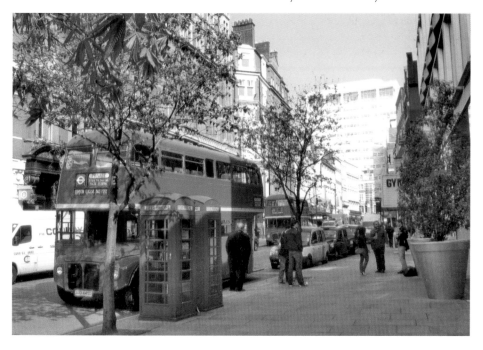

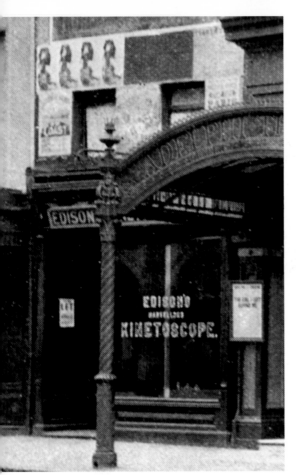

'Edison's Marvellous Kinetoscope' and the Adelphi Theatre, Strand, 1894

With its abundance of theatres, the Strand is another of London's show business centres but is less familiar as one of the places in Britain where movie film was commercially exhibited for the first time. First exploited publicly in New York in 1894, the Edison Kinetoscope was a peep-show machine which played short movie films on continuous loops. Blocks of the machines were installed in converted shops at a small number of locations in London including this one by the Adelphi Theatre. These viewing halls, effectively the first cinemas, lasted for a few months but technology was advancing into the newer world of the projected image. The Egyptian Hall in Piccadilly began showing 'animated photographs' in 1896 by which time the Kinetoscope houses had all closed.

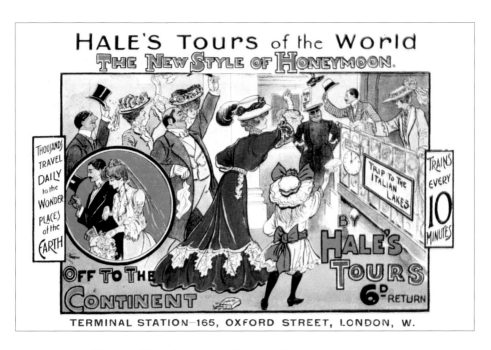

HALE'S Tours of the World
THE NEW STYLE OF HONEYMOON.

THOUSANDS TRAVEL DAILY to the WONDER PLACES of the EARTH

OFF TO THE CONTINENT

TRIP TO THE ITALIAN LAKES

BY HALE'S TOURS 6D RETURN

TRAINS EVERY 10 MINUTES

TERMINAL STATION–165, OXFORD STREET, LONDON, W.

Hale's Tours of the World, Oxford Street by Poland Street, 1906
Cinema was still something of a novelty in 1906 and dedicated movie houses were rare indeed. American inventor George Hale introduced a further novelty in 1906 when he brought his 'Tours of the World' to London. These shows took place in a small narrow auditorium which had been fitted out to resemble a railway carriage and included special effects created to give the impression of a train in motion, while short travel films were projected onto a screen at the end of the 'carriage'. The shows endured until around 1910 and from 1913 a new cinema was built on the site. By 1928 this had evolved into the Academy Cinema, which later closed in 1986.

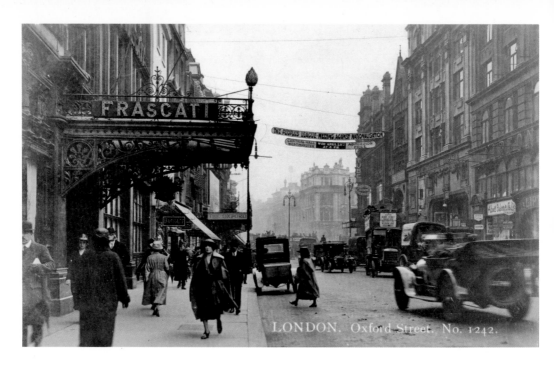

Oxford Street, Near Soho Street, c. 1920

The eastern section of London's renowned shopping street gives Soho its northern boundary and is marked here by the former Phoenix Cinema, right, which began in 1910 as the Pyke Cinematograph. The canopy on the left belonged to Frascati's Restaurant (1893) where an opulent winter garden was a great attraction. The Oxford Music Hall lay further along, but from 1966 everything has been overlooked by the towering Centre Point.